IMAGES
of Rail

ILLINOIS CENTRAL RAILROAD

WRECKS, DERAILMENTS, AND FLOODS

On the Cover: On April 25, 1948, the northbound Sunchaser derailed at Adamsville, Alabama, killing the engineer and fireman plus a passenger. The 4-8-2 locomotive No. 2459 and several cars slid into a deep ravine. Several days were required to rerail the locomotive. (Frank E. Ardrey Jr. photograph.)

IMAGES
of Rail

ILLINOIS CENTRAL RAILROAD
WRECKS, DERAILMENTS, AND FLOODS

Clifford J. Downey

ARCADIA
PUBLISHING

Copyright © 2016 by Clifford J. Downey
ISBN 978-1-4671-1599-5

Published by Arcadia Publishing
Charleston, South Carolina

Printed in the United States of America

Library of Congress Control Number: 2015950674

For all general information, please contact Arcadia Publishing:
Telephone 843-853-2070
Fax 843-853-0044
E-mail sales@arcadiapublishing.com
For customer service and orders:
Toll-Free 1-888-313-2665

Visit us on the Internet at www.arcadiapublishing.com

This book is in memory of railroaders everywhere who have died or been injured while on duty.

CONTENTS

Acknowledgments		6
Introduction		7
1.	An Ounce of Prevention	11
2.	Derailments	23
3.	Collisions	45
4.	Floods	67
5.	Grade Crossing Collisions	81
6.	Picking up the Pieces	95
7.	Odds and Ends	103
8.	The 1971 Tonti, Illinois, Amtrak Derailment	109
9.	The 1972 Chicago Suburban Collision	121

Acknowledgments

This book was not written using a single library, archive, or person. Instead, it was written using photographs and documents that I have collected since the mid-1980s. Each of the libraries and persons listed below contributed tidbits of information that made their way into this book.

The first library I ever visited was the Hopkinsville–Christian County Library in Hopkinsville, Kentucky. The patient staff taught me a number of research techniques, and they also taught me how to thread a microfilm reader. Those skills served me well in later years when I attended Murray State University in Murray, Kentucky, and spent countless hours in the library.

Staff members at the Newberry Library in Chicago, Illinois, and the National Archives filled several requests for specific documents. Additionally, through the years, I was able to tap the archives of the Illinois Central Railroad Historical Society (ICHS) in Paxton, Illinois. The ICHS has a large collection of Illinois Central–related photographs and records available to researchers.

Several persons, too many to mention, helped me understand "why" and "how" some of these wrecks happened. A special thank-you goes to Ted Lemen, who contributed several photographs and his knowledge of the 1972 suburban crash. Likewise, many sources contributed the photographs seen in this book. Several persons deserve special recognition, including Frank Ardrey Jr., Sam Harrison, Lee Hastman, Bill Raia, and Chris Thompson.

Every effort was made to identify all photographers whose work appears in this book. However, over the years, I have collected thousands of photographs, and many of them lack any type of identification, including the photographer's name. If an image is not credited to a specific person, then the photographer is unknown and the photograph came from my collection.

Finally, I want to thank my wonderful wife, Jolinne Balentine-Downey, and beautiful daughter, Rebecca Downey, for their continued love, patience, and understanding. While we were dating, Jolinne knew that I was addicted to trains and yet she married me anyway. Rebecca and I visited numerous antique stores when she was a young kid. She patiently waited as I dug through postcards and photographs, looking for anything related to the Illinois Central.

INTRODUCTION

"A book on train wrecks? Why would anyone write a book about train wrecks? Doesn't this guy know that people are hurt or killed in train wrecks?"

When I announced plans for this particular book, most folks were supportive, even enthusiastic. However, I did hear from several individuals who were skeptical. A couple of folks told me they were firmly against the book and thought it would be purely sensationalistic.

Because there are some folks who have asked, and may yet ask, "Why would anyone write a book about train wrecks," please let me explain. Back in 1974, when I was six years old, my parents moved to Pembroke, Kentucky. Our house was about 300 feet from a busy main line operated by the Louisville & Nashville Railroad. My bedroom was on the second floor, and I had a good vantage point to see both southbound and northbound trains as they rumbled through town.

For several years I just watched trains. But then in 1983, when I was 15 years old, I started photographing trains passing through town. And with help from my parents, I traveled to other towns in western Kentucky to photograph trains. I had my first train photograph published at age 16 and along the way became an avid fan of the Illinois Central Gulf Railroad.

The Illinois Central Gulf (ICG) was a relatively young railroad. ICG was formed on August 10, 1972, when the Illinois Central (IC) Railroad merged with smaller rival Gulf Mobile & Ohio (GM&O) Railroad plus two short line railroads in Mississippi. Both the IC and GM&O had rich histories. IC's roots dated back to February 10, 1851, when the road was chartered in Illinois. By 1900, the road had expanded west to Iowa and south to New Orleans. The GM&O's roots dated back to 1848. Like the IC, the GM&O stretched from the Gulf Coast to the Midwest.

In addition to reading every article and book I could find on the IC and ICG, I began talking to railroad employees. Many of them had worked in the railroad industry for 30 years or more and were willing to talk about their careers. Almost without exception, their stories were entertaining and informative.

I quickly learned that working on the railroad was often dangerous and difficult. Without exception, every locomotive engineer I have interviewed has had several "near misses" at grade crossing, and many engineers have been in at least one grade crossing accident involving serious injuries and/or fatalities.

Of course, grade crossing collisions are just one type of accident that can happen on the railroad. There are also derailments, washouts, fires, and collisions between trains. Crime is a serious problem in many urban areas. I have talked to several employees who admitted they carry firearms to work. These men and women "pack heat" even though it is against company policy and they may be fired if caught.

As I listened to these stories, a common thread developed. Many railroaders wanted their stories, both good and bad, to be preserved. With this in mind, the idea of writing a book about IC/ICG wrecks came to mind. I spent a lot of time debating whether to write this book because I knew some folks would think it was sensationalistic. After a great deal of debate and prayer, I decided

to proceed. However, I was determined to approach the subject in a historical manner and avoid speculation, rumors, finger pointing, and gossip. I am not trained in the science of investigating rail accidents. Thus, when writing about the cause of an accident, I have limited my remarks to those facts outlined in newspaper articles, company reports, and reports by investigating bodies like the Interstate Commerce Commission (ICC), the National Transportation Safety Board (NTSB), and the Federal Railroad Administration (FRA).

Furthermore, this book is not intended to be a comprehensive review of all IC/ICG accidents. Such a book would take years to write and would fill numerous volumes! Instead, it is intended as a pictorial history of selected accidents from the early 1900s through the early 1970s.

In order to keep things organized, the book is divided into nine chapters. The first chapter is titled "An Ounce of Prevention" and was intentionally put at the front of the book. The IC, like most railroads, invested heavily in technology and training to prevent accidents from ever happening.

Chapter two focuses on derailments, which are perhaps the most common type of accidents in the railroad industry. As with all rail accidents, there are many different causes for derailments, including broken rails, track that is out of gauge (i.e., too wide or too narrow between the rails), and shifting cargo that causes a car to tip over. And there are some causes that defy belief. On page 26 there are two photographs of the Panama Limited taken in 1937 after the train struck a cow and derailed.

Collisions between two trains is the subject of chapter three. These types of accidents tend to generate the greatest concern within the railroad industry. Train operations on the IC/ICG were governed by rule books and employee timetables. Each of these documents were chock full of rules, and most of those rules were intended to prevent a collision. When a collision occurs between two trains, investigators almost immediately look to see if a rules violation occurred.

Floods are the topic of chapter four. Several segments of the IC ran in close proximity to the Ohio and Mississippi Rivers and their tributaries. This made the railroad vulnerable to flooding, especially in the springtime. During most years flooding was a minor nuisance, but occasionally, it was downright catastrophic. In 1912 and 1927, the lower Mississippi River was hit by devastating floods. Both of these floods killed hundreds of people and caused millions of dollars in property damage. The IC sustained considerable losses during these floods.

One of the greatest floods in US history was the 1937 flood along the Ohio River Valley. Numerous railroads were hit hard by this flood, but the IC was probably hit the hardest. The IC's busy Kentucky Division between Louisville and Paducah, which supplied much of the IC's coal traffic, was flooded in several locations and was cut off from the rest of the IC system. And the IC's busy main line between Chicago and New Orleans was blocked for two weeks. As the floodwaters flowed south, severe flooding occurred along the lower Mississippi River. Every IC main line into Memphis experienced some flooding, and several routes had to be shut down entirely. At Vicksburg, Mississippi, floodwaters stood about eight feet deep in IC's yard. Several weeks passed before the railroad fully recovered from the flood.

As noted earlier, grade crossing collisions are a constant concern within the railroad industry. Throughout its history, the IC invested heavily in technology to prevent collisions between trains and highway vehicles. Chapter five looks at some of this technology, as well as the disastrous consequences of trying to beat a train at the crossing. The road also participated in the Operation Lifesaver program, which uses trained volunteers to give presentations to school students, civic groups, and others. Thanks to these efforts, the number of grade crossing collisions has dropped steadily since the early 1970s.

Chapter six is titled "Picking up the Pieces" and covers the men and machinery used to clear wrecks. From the late 1800s through the 1970s, most wrecks were cleared using massive rail cranes. These cranes were often called "big hooks" for the massive hook on their boom, used to attach stout lifting cables. Most big hooks had a lifting capacity of 100 to 150 tons. By working together, a pair of big hooks could lift even the heaviest locomotive.

But just like the railroad industry itself, the job of clearing wrecks underwent a dramatic change between the 1960s and 1980s. Contractors using specialized bulldozers and sideboom tractors took

over the task of rerailing cars and locomotives. Many rail observers were initially skeptical that the bulldozers were capable of clearing wrecks. But within a few years, the bulldozers had proven their value and most of the old-fashioned big hooks went to scrap.

When dealing with a topic as broad as railroad accidents, there are always a few events that cannot be neatly classified. Some of these events are covered in chapter seven, "Odds and Ends."

Because of their historical significance, two accidents are covered in their own separate chapters. Chapter eight is devoted to the tragic June 10, 1971, derailment of Amtrak's City of New Orleans passenger train at Tonti, Illinois. This derailment is notable for several reasons. First, it was Amtrak's first major accident. Second, the Tonti accident probably could have been prevented.

According to NTSB report RAR-72-5, the chain of events leading to the Tonti derailment began on June 6, 1971, when Amtrak's City of New Orleans departed Chicago, headed for New Orleans. The lead locomotive was E8A No. 4031, a twin-engine diesel locomotive that produced 2,250 horsepower. Soon after leaving Chicago, the rear engine in locomotive No. 4031 stopped producing power. The rear engine was isolated for the remainder of the trip. When the train arrived in New Orleans, it was discovered that the auxiliary generator attached to the rear engine had failed. Due to limited shop facilities in New Orleans, it was decided to return the locomotive to Chicago for repairs. The rear engine was shut down and a yellow "Do Not Start" tag was attached to the electrical panel to prevent the engine from being started. As an additional safety feature, the power reverser for the rear engine was put in neutral and a 3/8-inch steel pin was inserted to lock it.

Upon arrival back in Chicago, locomotive No. 4031 was sent to IC's Woodcrest shops on the south side. The auxiliary generator attached to the rear engine was replaced and tested, and the locomotive was cleared for service. However, the 3/8-inch steel pin in the electrical panel of the rear engine was not removed. The pin prevented the rear engine from producing power. More importantly, it disabled the locomotive's wheel slip alarm system. This system was designed to alert the crew if a wheel was slipping or if an axle locked up.

On June 10, 1971, locomotive No. 4031 was dispatched south to New Orleans as the lead unit on Amtrak's City of New Orleans. Near Mason, Illinois, the lead axle on No. 4031's rear truck locked up. However, due to the disabled wheel slip alarm, the engine crew did not receive a warning. Thus, the train continued its southbound journey, reaching speeds of 100 miles per hour. As the locked-up wheel skidded along the tracks, friction between the rail and axle gouged a false flange on the lead axle of the rear truck. A false flange, if not detected early, could cause a derailment. Sadly, that is exactly what happened as the train passed through the tiny community of Tonti, Illinois. Ten passengers and the conductor died, and 163 others were injured during the violent derailment.

Chapter nine is also devoted to a single accident, namely the collision of two commuter trains at Chicago, Illinois. As with many rail accidents, the collision was the result of a chain of events. Northbound commuter train No. 416, equipped with new lightweight "Highliner" cars, overshot the stop at the Twenty-seventh Street Station. Train No. 416 stopped and began backing to the station. Following close behind train no. 416 was train No. 720, equipped with older heavyweight cars. The motorman on train No. 720 was unaware that train No. 416 had stopped at Twenty-seventh Street and was backing up. The two trains collided and the rear car of train No. 416 was split open. Forty-five commuters were killed and 332 passengers injured in the deadliest wreck in IC/ICG's history.

The railroad industry has changed over the past 100 years, and so too has the science of investigating railroad reports. In 1910, the ICC ordered railroads to submit reports for accidents that caused death or serious injury to employees or passengers or more than $150 in damages to railroad property. Some railroads viewed this new regulation as yet more unwelcome government meddling, and some early wreck reports were little more than cursory reviews of an accident and the events leading up to them. With this in mind, the ICC took a more active role in railroad investigations, and by the late 1910s, methodical investigation techniques had been developed. Employees and eyewitnesses were interviewed, employment and maintenance records were searched,

and every stone was turned over in an effort to determine the cause of an accident. Occasionally, the ICC used facts uncovered during these investigations to issue new regulations.

In 1967, the task of investigating all major rail, highway, aviation, marine, and pipeline accidents was shifted to the newly-formed National Transportation Safety Board. Since the NTSB is independent of other government agencies, it can provide objective, unbiased reports that are not tainted by bureaucratic politics. Copies of many of the ICC and NTSB railroad accident reports can be found at the US Department of Transportation's National Transportation Library webpage at dotlibrary.specialcollection.net.

The Illinois Central Railroad no longer exists. On July 1, 1999, it was merged into the Canadian National Railway. Although this book might suggest otherwise, it must be noted that perhaps 99.99 percent of all train trips on the IC were completed without incident. This is a testament to the hard work and dedication to safety of the employees on the "Main Line of Mid-America."

One

AN OUNCE OF PREVENTION

Perhaps the best way to deal with railroad accidents is to prevent them from happening in the first place. Over the years, the Illinois Central aggressively sought to prevent accidents through several measures. One was the Rules and Regulations of the Transportation Department, better known as "the rule book." This book outlined the various rules that train crews were expected to follow. Each crew member was required to carry a copy of the rule book while on duty, and they were frequently tested on its contents.

In addition to the rule book, crew members also carried timetables for each district they operated over. The timetables carried even more rules, usually targeted to a specific location and situation.

Track maintenance was another method the IC used to prevent accidents. Almost without exception, a well-maintained railroad has fewer derailments than a poorly maintained one. The IC learned this lesson the hard way in the 1970s when track maintenance was cut back to save money. Almost immediately, the number of derailments began to climb. After securing a federal loan to pay for track repairs, the number of derailments began to fall.

To help keep trains moving safely and efficiently, the Illinois Central issued a rule book that was given to all employees involved with train operations. At the front of this 1942 book is the statement: "Obedience to the rules is essential to safety." The railroad employed examiners who routinely tested employees' knowledge of the rules.

RULES

AND

REGULATIONS

OF THE

TRANSPORTATION DEPARTMENT

EFFECTIVE JULY 1, 1942

REPRINTED SEPT. 1, 1944

Illinois Central Railroad

KENTUCKY DIVISION

TIME TABLE No.

33

Taking Effect at 12:01 a. m.

SUNDAY OCTOBER 25, 1959

Superseding
Kentucky Division Time Table No. 32
dated January 25 1959
and
Mississippi Division Time Table No. 15
dated October 26, 1958

FOR THE GOVERNMENT OF EMPLOYES ONLY

O. H. ZIMMERMAN, Vice President
E. H. BUELOW, General Manager
W. A. JOHNSTON, JR., General Superintendent Transportation
H. F. WILSON, Superintendent Transportation
W. E. DAVIS, Superintendent

The railroad also issued employee timetables (ETTs) for each district. Among other information, ETTs provided a list of stations in a district, its milepost, and a schedule for all trains that were regularly scheduled to run over the line. An ETT typically included rules or special instructions for a particular location or situation.

Before any train can move a single inch, its crew must have proper train orders issued by a dispatcher. To ensure that the dispatchers' orders were concise and lacked any confusing language, the road issued "Special Instructions To Train Dispatchers" as a supplement to the rule book and ETT.

ILLINOIS CENTRAL
RAILROAD

•

SPECIAL INSTRUCTIONS
TO TRAIN DISPATCHERS

•

EFFECTIVE JULY 1, 1959

Each division had its own dispatch office. Dispatcher James Thompson is seen here at his post in Carbondale, Illinois, in 1963. At the time, two dispatchers on each shift governed train movements on the St. Louis Division over a territory stretching from East St. Louis, Illinois, to Fulton, Kentucky, and south to Memphis, Tennessee, and Birmingham, Alabama. In 1969, train dispatching for the entire railroad was consolidated in Chicago.

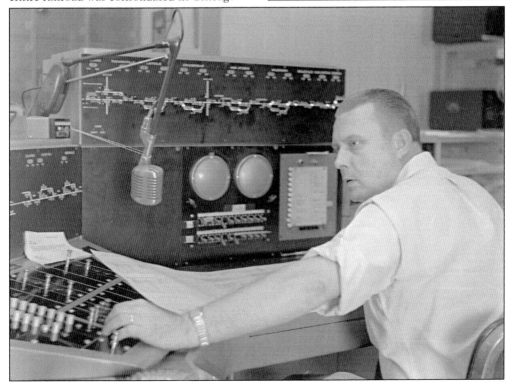

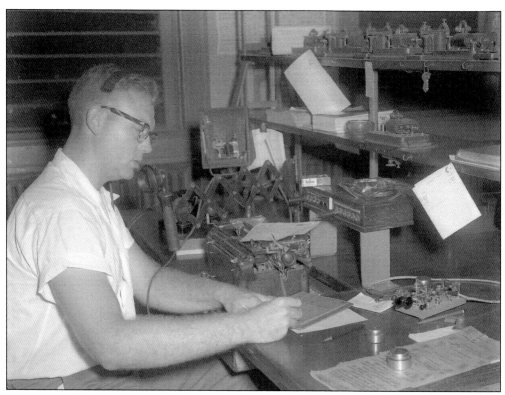

Dispatchers relayed train orders to operators scattered along the line. The operator made two copies of the orders, one for the engine crew and the second for the conductor and brakeman in the caboose. On July 23, 1958, operator Billy Hudson prepares orders in Louisville, Kentucky, for the crew of an outgoing train. (Illinois Central Railroad photograph.)

In 1967, an unidentified operator is seen passing train orders to the crew of a southbound freight train in Yazoo City, Mississippi. The orders were tied to a string and suspended between the two prongs of a Y-shaped fork. A crew member snagged the orders as the train passed. The orders were sometimes called "flimsies" for the tissue-like paper they were written on.

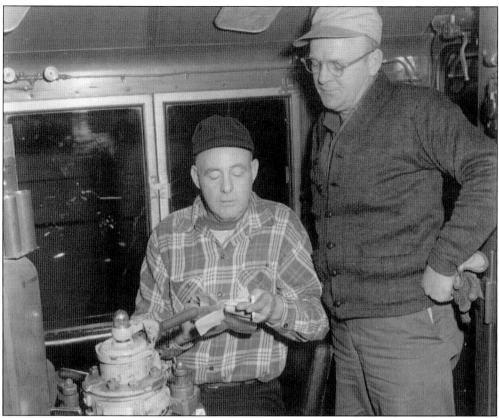

After a train crew received their orders, each crew member was required to read them. Here, engineer M.F. Stacy (left) and conductor C.R. Lee read their orders before departing Chicago with a southbound freight train in January 1956. (Illinois Central Railroad photograph.)

Timetables and train orders were of little use to train crews if they did not know what time it was. Thus, every train crew member was required to carry a watch. Crew members had to check their watch against a master clock when they started their shift. The road also employed special inspectors who regularly checked the watches of train crews to ensure they were accurate.

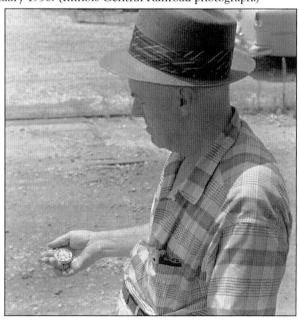

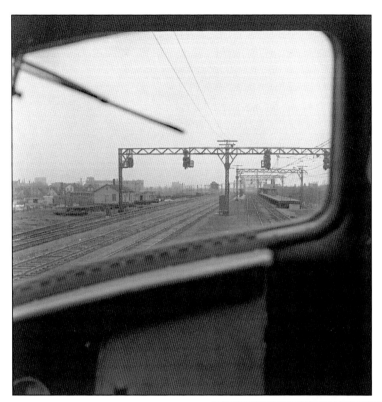

The IC relied heavily on specialized signals to keep trains moving safely. Like highway traffic signals, these signals indicated if a train could proceed or had to stop. The IC's signals also dictated a train's maximum speed and if a train was about to diverge onto an alternate route. Several overhead signals are visible here from the cab of a southbound passenger train leaving Chicago around 1955.

Between Champaign and Branch Junction, Illinois (north of Centralia), the IC also used Automatic Train Stop (ATS). This system was also installed between Waterloo and Fort Dodge, Iowa. Special boxes in the locomotive cab received signal indications. The system also stopped a train if it was going too fast for signal indications or ran a red light. High installation and maintenance costs prevented its use system-wide.

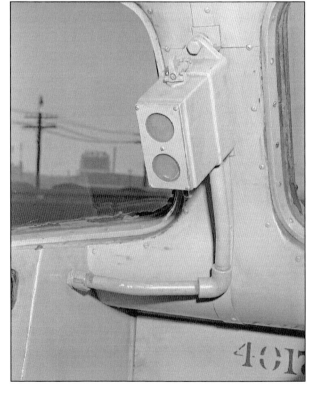

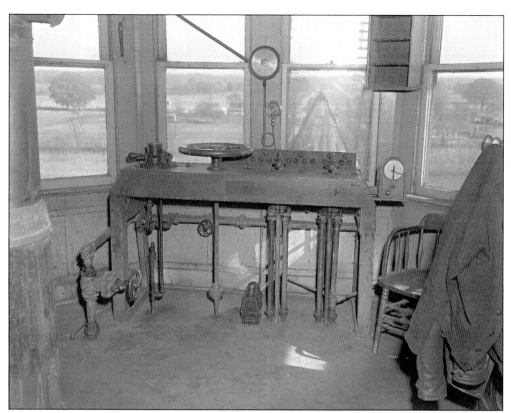

At drawbridges, the signals were also interlocked with the mechanism that moved the bridge. Thus, a train could not receive a "clear" signal unless the bridge was locked in place. Likewise, signals on both sides of the bridge would indicate "stop" if the bridge were open. These two photographs were taken inside the drawbridge at Eureka, Kentucky. The IC's main line between Louisville and Paducah, Kentucky, crosses the Cumberland River at this point. The photograph above illustrates the mechanism used to move the bridge, while the image at right shows the levers used to change signals. More photographs of the Cumberland River bridge can be found on pages 105–106. (Both, Illinois Central Railroad photograph.)

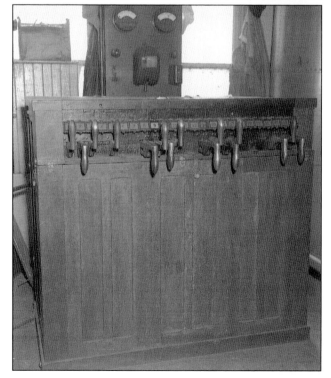

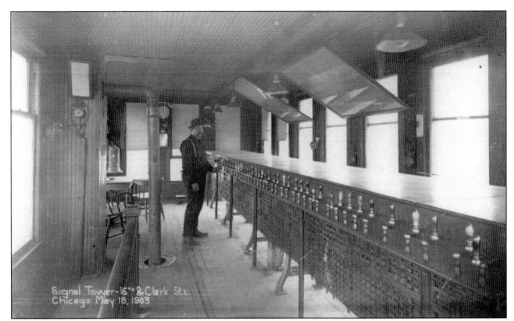

At hundreds of locations, the IC crossed other railroads, or two different IC routes crossed. Interlocking signals were used at many of these locations to prevent collisions. The signals are linked together so that crisscrossing routes cannot both receive a clear signal. One of the more complex interlocking towers was located in Chicago at Sixteenth and Clark Streets, seen here in 1903. (Illinois Central Railroad photograph.)

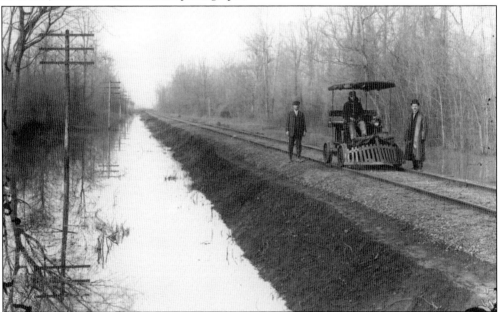

Regular inspection is necessary to catch broken rails, damaged ties, washed out roadbeds, or debris on the tracks that may cause an accident. An inspection party is seen here around 1910 at an unidentified location. The gasoline-powered "speeder" is outfitted with an impressive pilot, or cow catcher, plus a headlight, kerosene lamps, and even a horn. (Illinois Central Railroad photograph.)

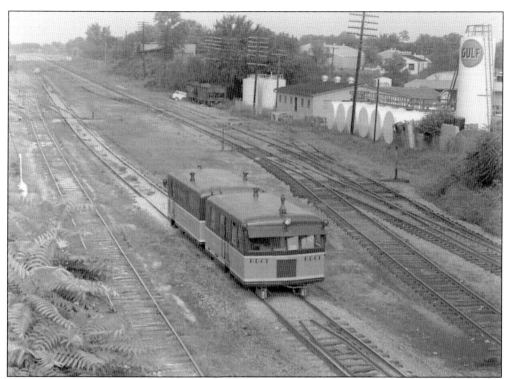

In addition to using human eyes to inspect the track, IC owned two cars that searched for defects hidden inside a rail. Cars RDC-1 and RDC-2 (Rail Detection Car) were built at IC's Burnside Shops on the south side of Chicago in the 1940s. These cars used magnetic forces to identify defective rails. Car RDC-1 is seen passing through Dyersburg, Tennessee, in 1964. (Chris Thompson collection.)

At the rear of an RDC is a control panel. If a defective rail is detected, a distinctive mark is made on a large paper scroll. The car then stops, and the potential defect is checked more thoroughly. C.H. Rankin (left) watches the paper scroll intently. Meanwhile, James Fox looks for a spot of white paint that is automatically sprayed at the site of a defect. (Chris Thompson collection.)

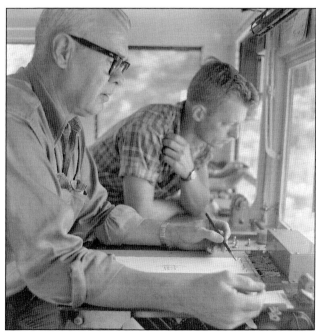

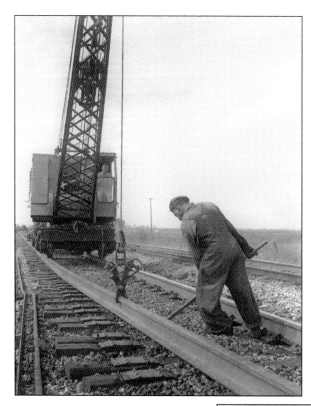

Constant track maintenance is also necessary to prevent accidents. Beginning in the 1940s, the railroad began installing Continuous Welded Rail (CWR) on heavily trafficked lines. CWR eliminated the traditional "clickety-clack" of old jointed rail, and also created a smoother ride for trains and reduced the number of broken rails. The two photographs on this page were taken around 1965 near Champaign as a track gang lays CWR. (Hedrich-Blessing photograph.)

A track worker uses a hydraulic spike driver to complete installation of the new CWR. The importance of constant maintenance became painfully evident in the 1970s as the railroad cut back on track maintenance to save money. The number of derailments skyrocketed, and the road had to reduce train speeds on many lines due to poor track. (Hedrich-Blessing photograph.)

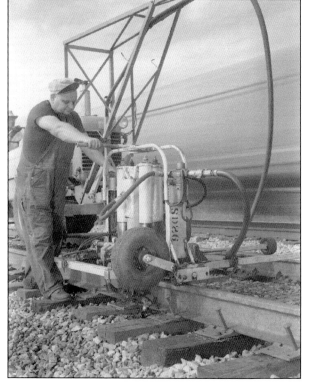

"Hotbox" is railroad jargon for an overheated bearing on a car or locomotive. These hotboxes, if not detected, can cause the bearing to burn off the axle. Throughout the years, countless derailments have been caused by hotboxes. In response, railroads began installing hotbox detectors to catch these defects. This particular detector was photographed around 1965 along the IC main line north of Memphis. (Hedrich-Blessing photograph.)

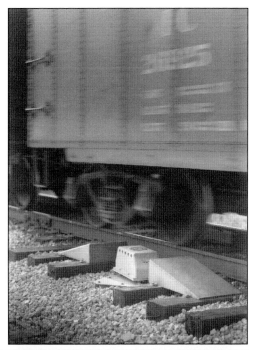

For decades, train crews used whistles and hand signals to communicate with each other. This system usually worked as intended, but numerous accidents occurred when crew members either missed or misinterpreted a signal. In the 1940s, the railroad began experimenting with radios. By the mid-1960s, most locomotives and cabooses had been equipped with radios, and most crew members working the ground had handheld radios. (Hedrich-Blessing photograph.)

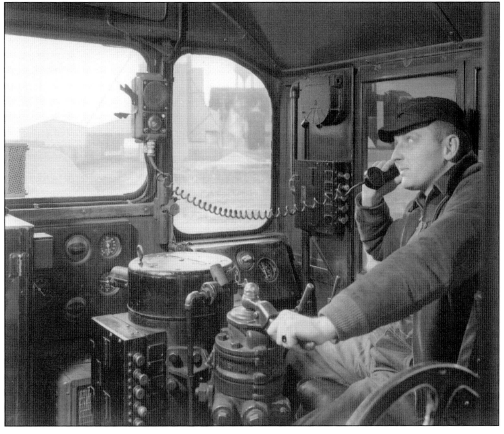

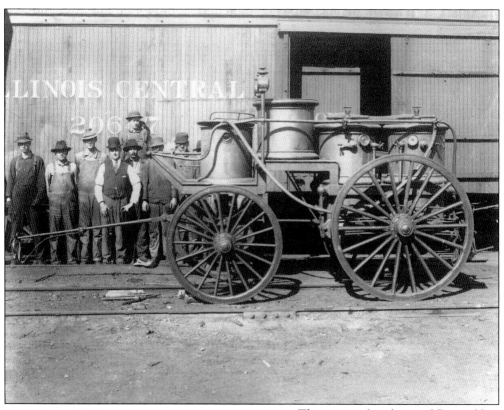

There is an abundance of flammable liquids and materials to be found on a railroad. For this reason, railroads have always been concerned about fire. Most larger shops on the IC had their own fire brigades that could rapidly be deployed during a fire. This crew was photographed around 1915 at an unknown location. (Illinois Central Railroad photograph.)

Cabooses also played a key role in preventing accidents. The cupola atop the car provided a great vantage point to catch hotboxes or dragging freight. But they could also be dangerous. Many crew members were injured or even killed after being thrown around inside a caboose. (Hedrich-Blessing photograph.)

Two

Derailments

Derailments are perhaps the most common type of accident on the railroad. Thankfully, most derailments are minor and do not involve injuries or property damage. But when a major derailment occurs, it has the opportunity to be spectacular. One example was the 1948 derailment of the Sunchaser passenger train near Adamsville, Alabama. The locomotive and several passenger cars derailed and slid into a deep ravine, killing the engineer, fireman, and a passenger.

Sometimes a derailment can be a public relations black eye, such as the 1974 derailment of a loaded coal train atop Kentucky Dam, seen on pages 42–44. By this time, the railroad had been renamed the Illinois Central Gulf (ICG). In addition to ICG's tracks, US 62 crossed the dam. The derailment took place in full view of thousands of drivers and passengers, causing even more embarrassment for the ICG.

Hotboxes, overheated journal boxes, have historically been a leading cause of derailments. However, the introduction of roller bearings and magnetic testing of rails to find defects have caused the number of derailments to decline sharply. But there are many factors that could possibly cause a derailment, and thus, railroads and their employees must always remain vigilant.

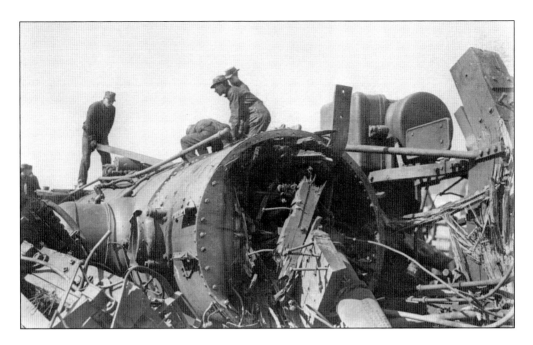

During the early 1900s, it was not uncommon for photography studios to take photographs of local disasters and then make real-photo postcards for resale. These postcards are actual photographs, but printed on heavier paper than normal photograph paper, with postcard markings on the back so they can be mailed. Around 2:10 a.m. on May 29, 1918, westbound IC passenger train No. 11 hit a washed-out bridge near Applington, Iowa. Six crew members were killed, and 27 passengers and crew were injured. Later that same day, an unidentified local photographer visited the scene and recorded the derailment. Afterwards, the photographer produced a series of at least four real-photo postcards, including the two seen here. (Both, author's collection.)

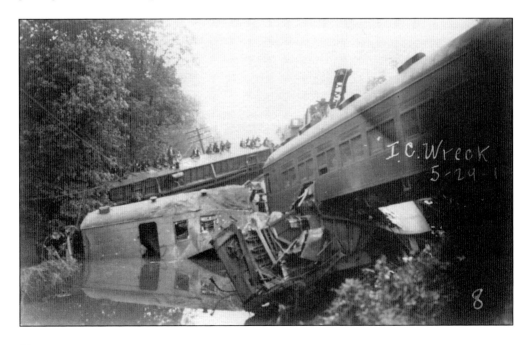

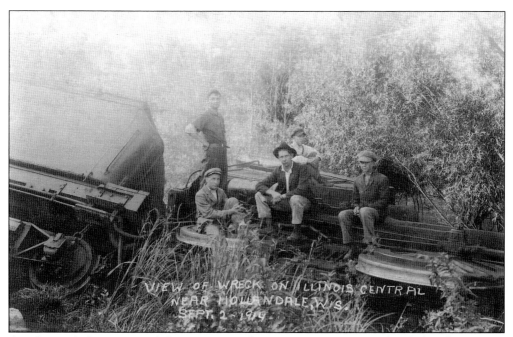

Another real-photo postcard shows a group of young men posing on a derailed IC locomotive near Hollandale, Wisconsin, on September 2, 1914. Train accidents often turned into impromptu social events, with large crowds visiting the wreck site, posing for photographs, and sometimes climbing onto the wreckage.

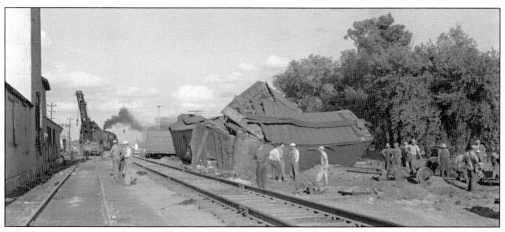

Winthrop, Iowa, was the site of this 14-car derailment. At approximately 4:45 a.m. on August 31, 1949, an eastbound freight train was pulling into the siding to clear the main line for a westbound passenger train. One of the cars apparently "picked the switch;" in other words, one set of wheels continued straight on the main line rather than going into the siding. (Chris Thompson collection.)

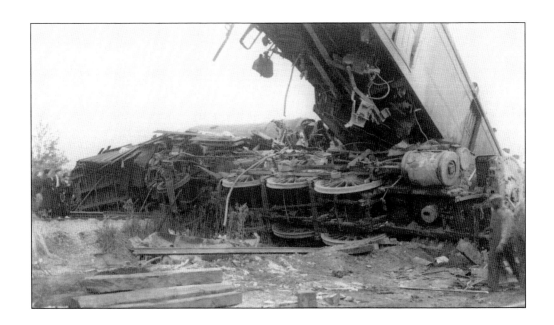

Some wrecks are simply bizarre, including the November 4, 1937, derailment of the southbound Panama Limited passenger train near Tallahatchie, Mississippi. At approximately 1:35 a.m., while traveling about 55 miles per hour, the train struck a cow. The bovine was pulled underneath locomotive No. 1187, causing the locomotive and eight cars to derail. The engineer and fireman were killed, and four others were injured. During the derailment, the locomotive fell on its side and the train's third car, a mail storage car, came to rest atop the heavily battered locomotive. (Both, C.C. Grayson photograph.)

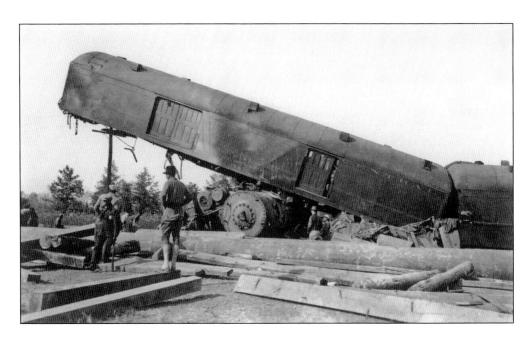

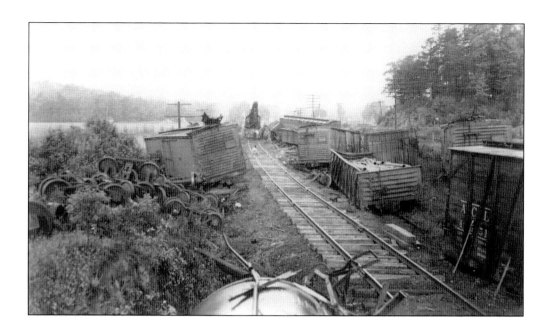

The date and location of these two photographs is uncertain, but they are believed to have been taken in Mississippi in the early 1940s. In the photograph above, the wrecker eases past derailed cars that have already been moved off the tracks. These wreckers were widely known as "big hooks" for the massive hook on their boom. Below, members of the wreck crew inspect the carnage. Although the tracks have reopened, their work is far from over. The derailed cars have to be rerailed, and repairs have to be made to the track. Wreck crews usually were shop workers, such as boilermakers, machinists, and mechanics. When called to work on the wrecked train, they typically lived in bunk cars, often for several days, until the wreck site was fully cleaned.

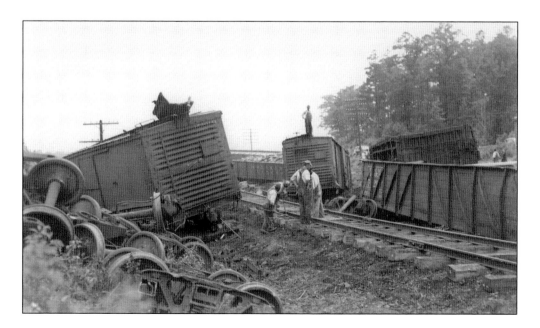

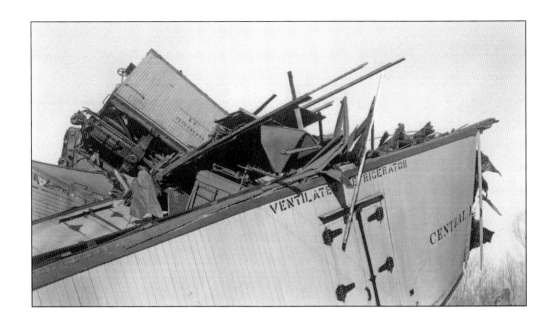

It may be surprising to learn that the Illinois Central was the top rail carrier of bananas. The railroad hauled its first carloads of the tropical fruit in the late 1800s. The traffic grew rapidly, and soon dozens of "banana trains" were departing New Orleans each week over the IC, headed north to Chicago and other Midwest cities. Bananas and other fruit were transported aboard wooden "reefers" cooled by large blocks of ice. These cars were cheap to build and maintain but could easily be turned into kindling, as vividly illustrated by these four photographs of a banana train derailment at Mikoma, Mississippi, on February 4, 1941. The car above has had its roof almost totally ripped off, while three other cars have substantial damage to their sides. (Both, C.C. Grayson photograph.)

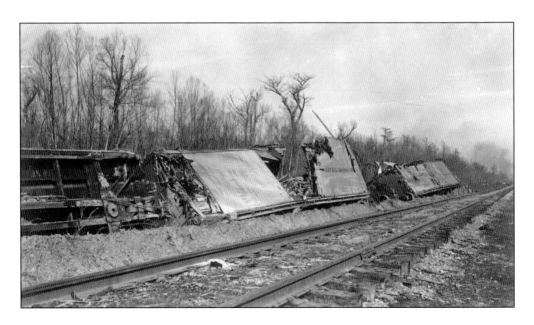

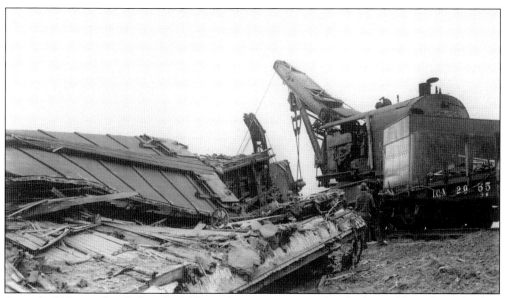

A total of 23 cars derailed in the Mikoma banana train wreck, which was blamed on a broken rail. The big hooks from both Jackson, Mississippi, and Memphis were on hand to clear the debris. Mikoma is along IC's main freight route between Memphis and New Orleans. Numerous trains were delayed or detoured due to the wreck, and officials were eager to reopen the tracks. (C.C. Grayson photograph.)

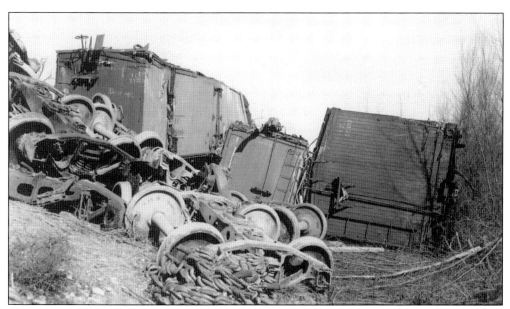

These derailed cars have been moved off the tracks and placed here by the wrecking crew as they work to clean up the Mikoma wreck. Crews will later haul off the cars that can be fixed and scrap those that are beyond repair. As for the bananas that were inside the cars, some of them undoubtedly were given to local families. (C.C. Grayson photograph.)

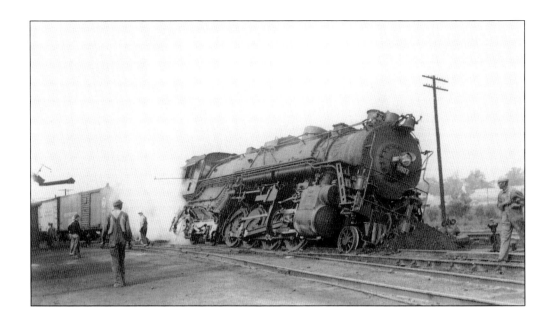

Details of this accident are unknown, but 2-8-4 locomotive No. 8003 created quite a mess when it derailed in the freight yard at Jackson on May 3, 1941. Shortly after the accident, crews assess the situation while 8003 vents steam from underneath the cab. In addition to derailing, locomotive No. 8003 has tilted towards the fireman's side and has gouged a large hole in the ground. Rerailing the locomotive and tender will be a formidable task. The locomotive by itself weighs approximately 398,000 pounds, and the tender weighs another 286,000 pounds when fully loaded. (Both, C.C. Grayson photograph.)

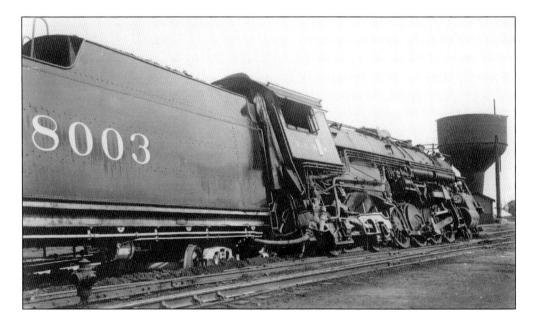

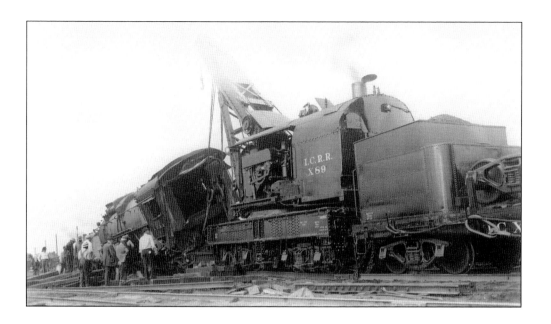

Like most IC wreckers, No. X-89 was steam powered. As seen above, coal and water were stored in a cut-down steam locomotive tender that was mounted on a flatcar. Rerailing locomotive No. 8003 required the combined efforts of man and machine to extract it from the big hole it plowed. Several large, heavy timbers were brought in to support the locomotive, as seen below. In a few hours, the locomotive was back on the rails, the tracks were repaired and reopened, and big hook No. X-89 went into hibernation until the next accident. (Both, C.C. Grayson photographs.)

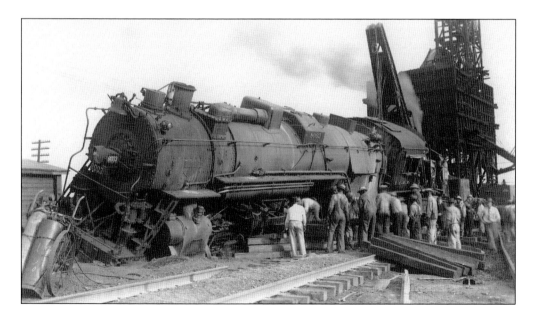

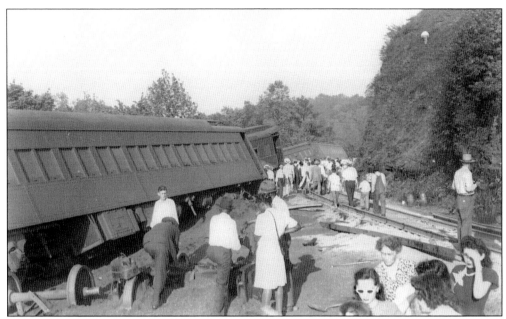

One of the IC's lesser known passenger trains was the Sunchaser. Inaugurated on December 17, 1941, the train operated between Chicago and Miami during the winter season (it was cancelled between 1943 and 1946 due to World War II). The train gained some unwanted publicity when it derailed on April 25, 1948, while traveling northbound near Adamsville, Alabama. (Frank E. Ardrey Jr. photograph.)

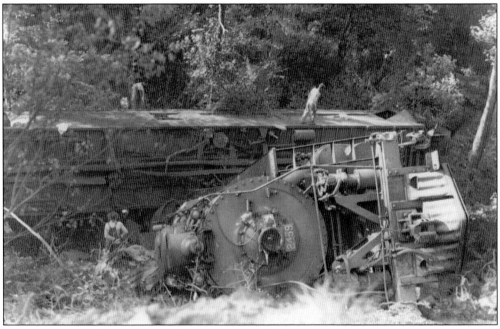

A passenger, plus the engineer and fireman, were killed during the Sunchaser derailment. Several cars and the locomotive slid into a deep ravine. The 4-8-2 locomotive No. 2459 is seen here at the bottom of the ravine, with the smashed remnants of a baggage-dormitory car lying atop the tender. (Frank E. Ardrey Jr. photograph.)

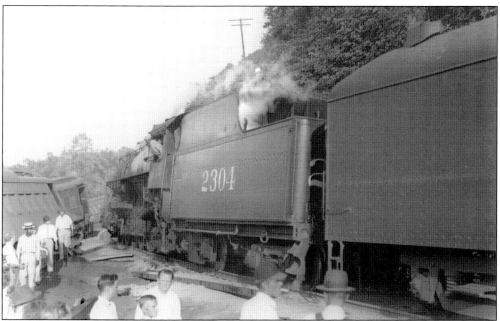

By late afternoon on April 25, the derailed cars had been moved out of the way and temporary repairs had been made to the tracks, allowing train traffic to resume. One of the first trains through was the southbound passenger train Seminole, which ran between Chicago and Jacksonville, Florida. The fireman is leaning far out of the cab, watching the track intently as his train passes. (Frank E. Ardrey Jr. photograph.)

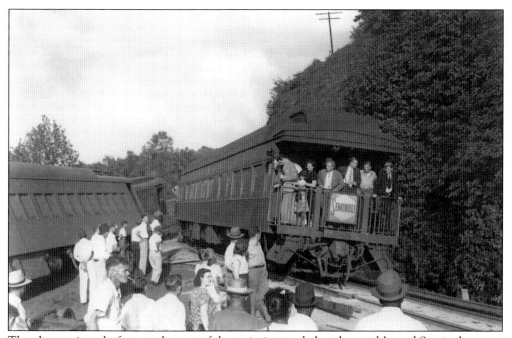

The observation platform at the rear of the train is crowded as the southbound Seminole creeps pass the derailed Sunchaser. A large crowd of curious locals has also gathered to inspect the wreckage. (Frank E. Ardrey Jr. photograph.)

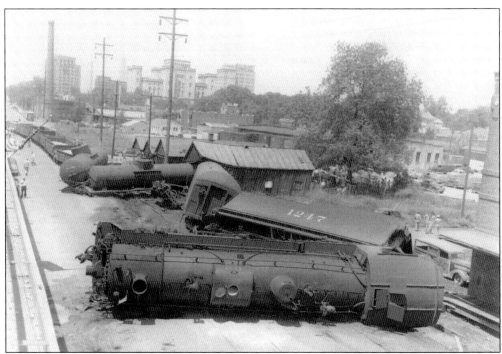

Human error caused this Illinois Central Railroad freight train to derail in Baton Rouge, Louisiana, in 1950. A train crew left a switch open after switching freight cars at a factory. The next train to come along hit the open switch, throwing the train into the siding and causing 2-8-2 locomotive No. 1247, a baggage car, and several freight cars to derail. Locomotive No. 1247 flipped onto its left side, providing the rare view below of the underneath of a steam locomotive. It was built in April 1915 by the Lima Locomotive Works of Lima, Ohio, and originally was numbered 1749. In April 1949, the locomotive was rebuilt at IC's shops in Paducah and renumbered 1247. After the Baton Rouge wreck, it was repaired and served until 1955, when it was scrapped. (Both, Wilbur Golson photograph.)

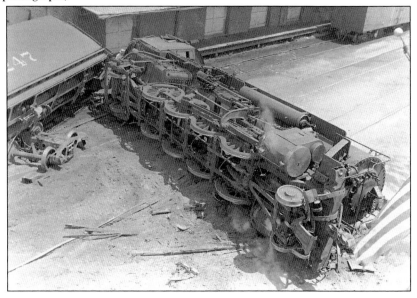

Notwithstanding the deadly 1972 collision, IC's Chicago suburban passenger service had an excellent safety record. However, from time to time, there were occasional minor mishaps, as illustrated by these two photographs taken on a frigid November 28, 1955. A string of empty cars derailed near downtown Chicago as the train headed downtown to pick up passengers at the Randolph Street terminal. (Sam Harrison collection.)

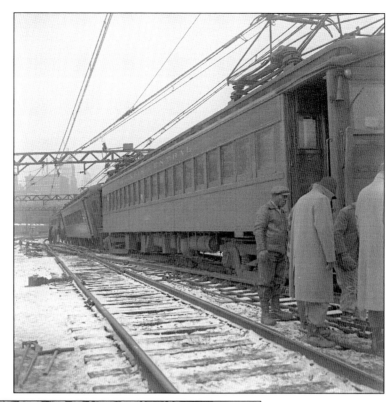

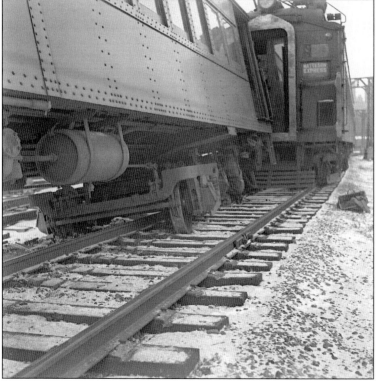

This view is on the opposite side of the train. A carman has crawled underneath the derailed car to unhook the cables and hoses between these two cars. The men on the wrecking crew often risked their lives by crawling into wreck debris. (Sam Harrison collection.)

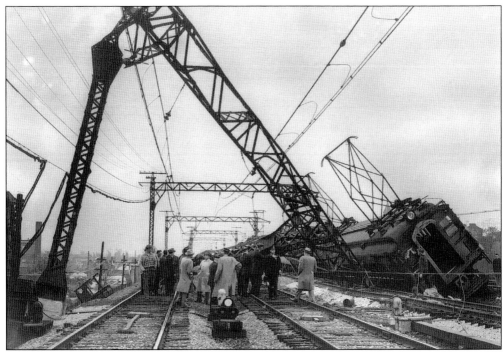

A far more serious accident occurred during the morning commute on October 21, 1959, when an eight-car suburban train derailed near Kensington on Chicago's far south side. Five cars jumped the tracks, and during the derailment, one of the towers supporting the overhead catenary was knocked down. Incredibly, only 11 passengers were injured, and most were out of the hospital within a couple hours. (Sam Harrison collection.)

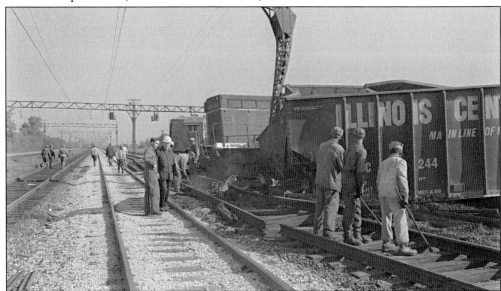

Any disruption to IC's Chicago-area suburban service, no matter how minor, was capable of disrupting the commuting schedule for thousands of workers. Around 1970, a freight train derailment has dumped cars onto one of the tracks used by the suburban trains. A track gang is already busy at work, and soon the big hook will move in to clear the tracks. (Chris Thompson collection.)

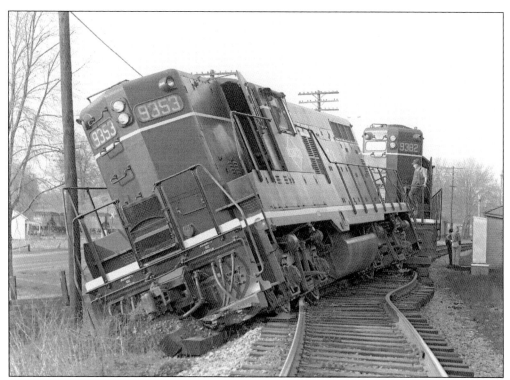

On April 7, 1959, a coal train split a switch at McHenry, Kentucky, approximately 111 rail miles south of Louisville. Locomotive GP9 No. 9353 was thrown into the ditch and sister GP9 No. 9382 was left leaning to one side. The derailment was relatively minor, and both locomotives were soon back in service. However, the wreck fouled train movements on the busy Kentucky Division. It is a safe bet that wreckers from Louisville and Paducah were already en route when these photographs were taken. (Both, Chris Thompson collection.)

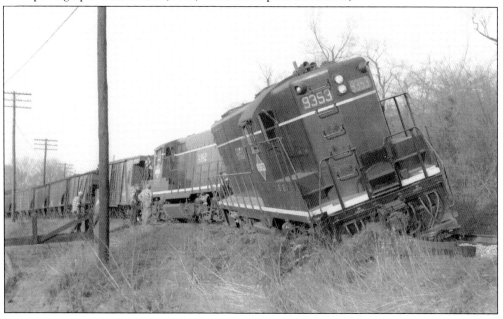

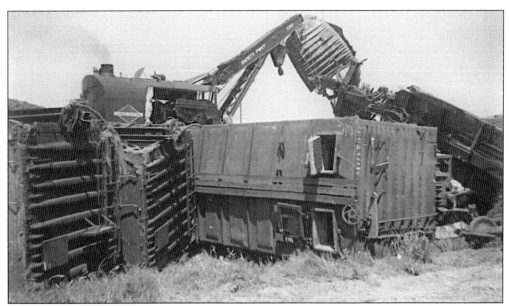

On July 10, 1957, the peace and quiet in tiny Brazil, Mississippi, was broken when 23 cars of northbound train NC-6 derailed. Twelve boxcars loaded with Masonite jumped the tracks, along with one car loaded with hardwood flooring and 10 empty cars. Wreckers from Memphis and Jackson were called in to clear the wreck. (Sherry Raggett collection.)

The derailment at Brazil was blamed on an overheated bearing. Prior to the 1960s, most freight cars rode on friction bearings. These bearings, at each end of an axle, required regular lubrication. If a bearing overheated and was not quickly detected, it could burn off, causing a derailment. Since 1968, all new freight cars have been equipped with roller bearings, which are less prone to overheating. (Sherry Raggett collection.)

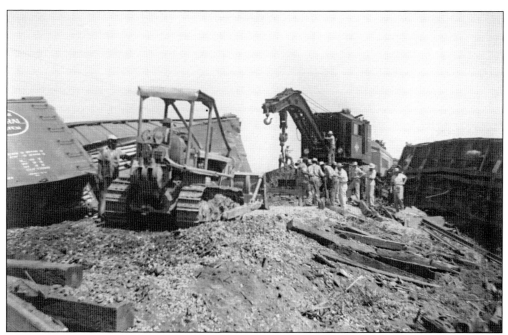

For decades, most rail accidents were cleared using the rail-mounted big hook. But beginning in the 1950s, a few roads began using specially equipped bulldozers with side boom and winches to clear wrecks. These small yet powerful machines could reposition themselves faster than traditional wreckers and could get into spots that were off limits to wreckers. The photograph above was taken at Brazil, Mississippi, on July 10, 1957, while the photograph below was taken at Hodgers, Alabama, on June 14, 1957. These are the earliest known photographs of bulldozers being used to clear wrecks on the IC. (Both, Sherry Raggett collection.)

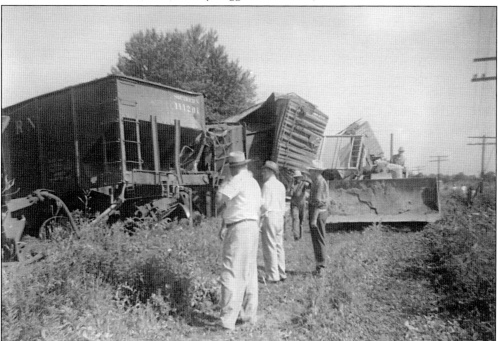

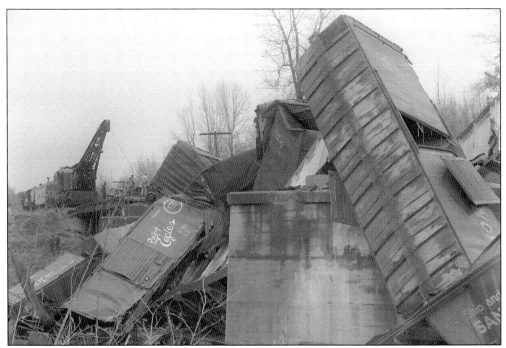

A bridge across Cole Creek near Fayette, Mississippi, collapsed on February 18, 1963, as an IC freight traveled across. Three locomotives made it across safely, but 40 cars fell into the stream. Tangled boxcars and remnants of the destroyed bridge are visible in the foreground as a wrecker crew from Jackson begins cleaning up the mess.

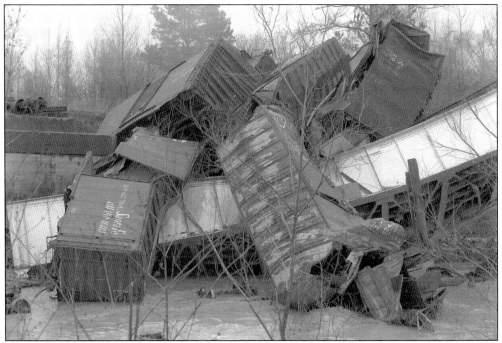

"Ship and Travel Santa Fe All The Way" is painted on the boxcar at lower left. However, neither the Santa Fe nor the Illinois Central welcomed the publicity generated by these types of wrecks.

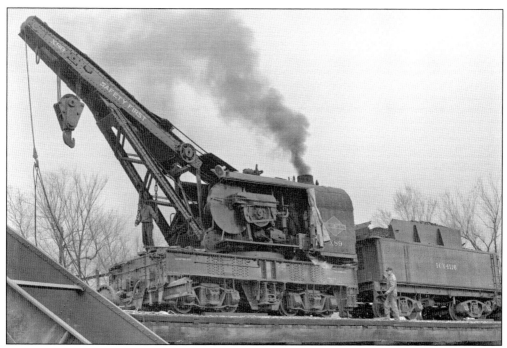
Big hook No. X-89 moves into position to clean up the Cole Creek wreck. This steam-powered crane was built in January 1908 by the Shaw Electric Crane Company and could lift 100 tons.

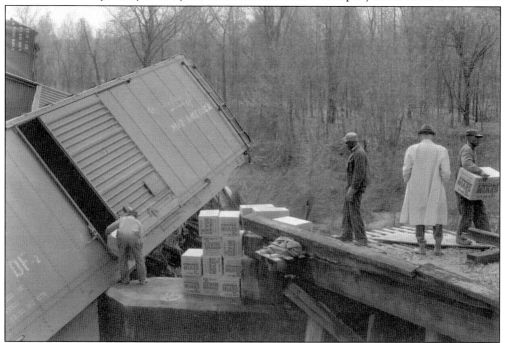
Railroads are responsible for damaged or destroyed freight. Thus, after a derailment, efforts are made to salvage freight from damaged cars where practical. In this view, workers are removing cartons of Sevin insecticide from a boxcar involved in the Cole Creek wreck. Although the car appears to be in a precarious position, it is actually firmly wedged into the wreckage.

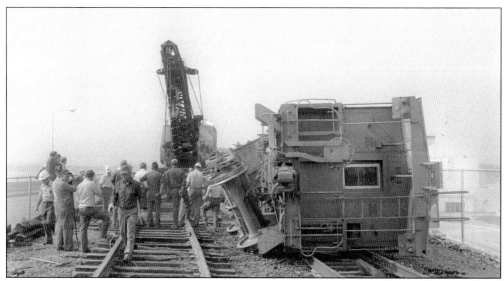

There is never a good place or time to have a derailment, especially atop a dam. In September 1974, a loaded coal train derailed atop Kentucky Dam, approximately 25 miles east of Paducah. The dam spans the Tennessee River and holds back Kentucky Lake, which at 184 miles long is one of the longest man-made lakes in the eastern United States.

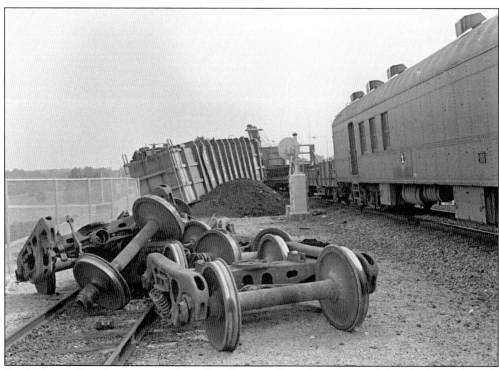

In addition to the caboose, several loaded coal hoppers flipped over. Once the tracks were reopened, crews came back to scoop up the spilled coal.

The wreck at Kentucky Dam was cleared by big hook No. 100409, assigned to Paducah. This crane had a lifting capacity of 120 tons, which is far greater than the weight of the freight car truck it is lifting. Built in July 1918 by the Industrial Works of Bay City, Michigan, the crane was originally steam powered. In 1954, the crane was rebuilt with a diesel engine.

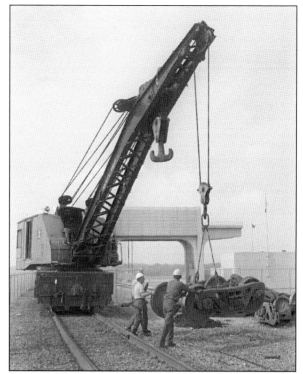

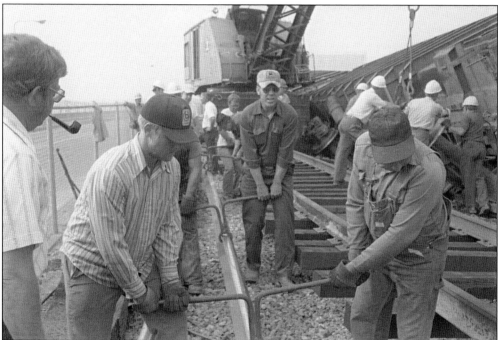

Even with the help of big hook No. 100409, plenty of manpower was needed to clear the Kentucky Dam derailment. Under the supervision of a pipe-smoking foreman, eight men use special tongs to lift a broken rail out of the way. Note that half the men are not wearing hard hats, and several are not even wearing gloves!

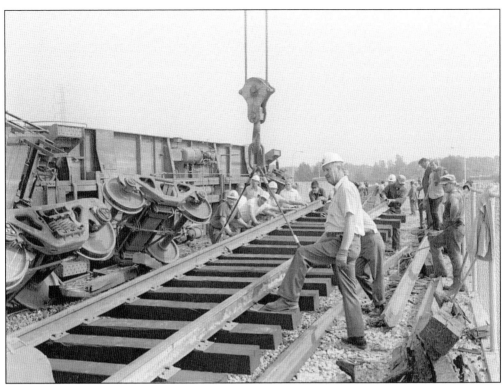

To help expedite the clean-up process, the damaged ties and rails were replaced with panel track, as seen above. The panel track was assembled beforehand by laying ties on the ground and spiking down tie plates and 39-foot-long sections of rail. The completed sections, called panels, were then loaded onto flatcars assigned to the wreck train. When needed, the panel track was unloaded and installed. Of course, the panel track did not always fit neatly into place. Below, a worker is using a cutting torch to trim a couple inches off a rail so the panel track will fit into place.

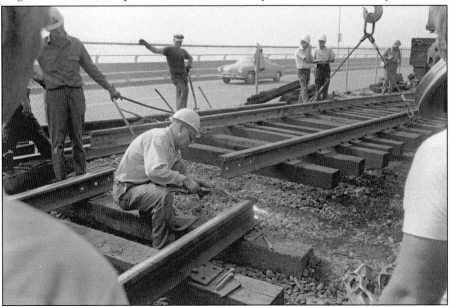

Three

COLLISIONS

Collisions between two trains are rare, but they can cause more damage and casualties than a derailment. Over the years, railroads have adopted several different types of technology in an effort to prevent collisions. Perhaps the oldest are automated block signals, first developed in the late 1800s. With this type of signal system, a line is broken into segments, each called a block. Each block is typically two to three miles long. At the beginning of each block is a signal. If there is no train in the block, the signal displays "clear" and a train can proceed. If there is a train in the block, the signal automatically displays "stop."

Automatic block systems are not without their flaws. Trains could still run past a stop signal and cause a collision. To help prevent this, a new type of signal system called Automatic Train Stop was installed between Waterloo and Fort Dodge, Iowa, and between Champaign and Branch Junction, Illinois. If a train ran past a stop signal, its brakes were automatically applied. This system helped reduce the number of collisions and near misses, but the high cost of installing and maintaining these types of signals prevented their use across the entire system.

A third type of signal system began appearing on IC lines in the 1930s. This system was called Centralized Traffic Control (CTC). With CTC, all signals and switches along a line are controlled from a central location, hence the name. Due to its high cost, the IC installed CTC only on certain routes with a high density of trains.

At this time, all major railroads (including Canadian National, which succeeded the IC) are being mandated to install a new system called Positive Train Control (PTC). In some ways, PTC is a 21st-century version of Automatic Train Stop, using wireless technology and advanced signals to prevent collisions. Railroads originally were given until December 31, 2015, to install PTC, but due to the complexity of the system, a three-year extension was granted.

Without a doubt, the most famous Illinois Central wreck took place at 3:52 a.m. on April 30, 1900, at Vaughan, Mississippi. A southbound New Orleans Special passenger train, with John Luther "Casey" Jones at the throttle, rear-ended freight train No. 83. Jones was killed instantly, and four others were injured. The wreck might have faded into history if not for Wallace Saunders, an engine wiper at IC's roundhouse in Canton, Mississippi. Saunders wrote a tune about Jones, which came to the attention of several vaudeville performers. Jones became legendary as the brave engineer who told his fireman to jump and rode his engine to doom. However, like most legends, Jones's story is often embellished. This often published photograph is the only verified image of Jones at the throttle of a locomotive. Two museums in Jones's hometown of Jackson, Tennessee, keep his legacy alive. The City of Jackson operates a museum near downtown that covers all railroads operating in Jackson. And just off Interstate 40, the for-profit Casey Jones Museum and Home allows visitors to walk through Jones's last home.

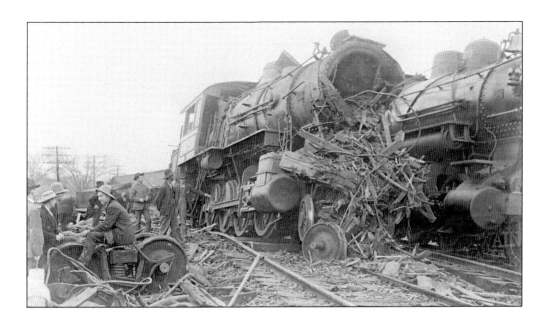

Train collisions during the late 1800s and early 1900s were often quite spectacular since most cars were built of wood. Around 11:15 p.m. on January 11, 1907, a northbound freight rear-ended another freight at Bardwell, Kentucky. During the collision, "dozens of box cars [were] reduced to kindling wood" according to the *Paducah Evening-Sun*. That number was probably exaggerated, but there is no denying the wreck was violent and deadly. Three or four railroaders (there are conflicting newspaper reports) and a hobo were killed. The main line was blocked for nearly a day before wreckers from Paducah and Fulton, Kentucky, could clear the line and repair the tracks.

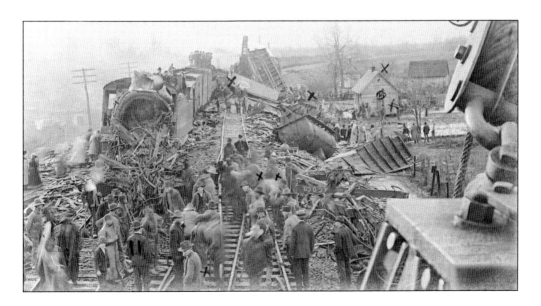

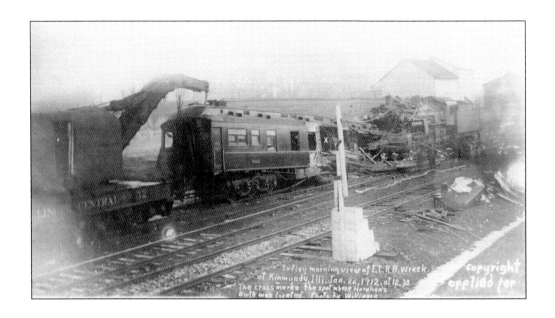

Shortly after midnight on January 22, 1912, southbound passenger train No. 25 stopped at Kinmundy, Illinois, to take water. At the tail end of train No. 25 was an office car owned by the Chicago Rock Island & Pacific Railroad (CRI&P). Almost immediately after stopping, train No. 25 was rear-ended by passenger train No. 3, the Panama Limited. The wooden CRI&P office car was demolished, killing four of its occupants, including James T. Harahan Jr., retired president of the Illinois Central; E.E. Wright of the Illinois Central's legal department; Frank Melcher, CRI&P vice president, and E.B. Pierce, CRI&P general solicitor. The men were headed to Memphis where they were to meet with other railroad executives interested in building a railroad bridge across the Mississippi River at Memphis. The bridge, completed in 1916, is named in honor of Harahan.

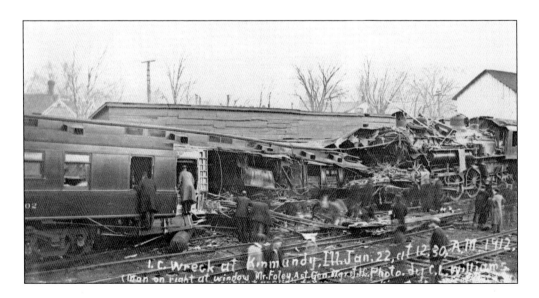

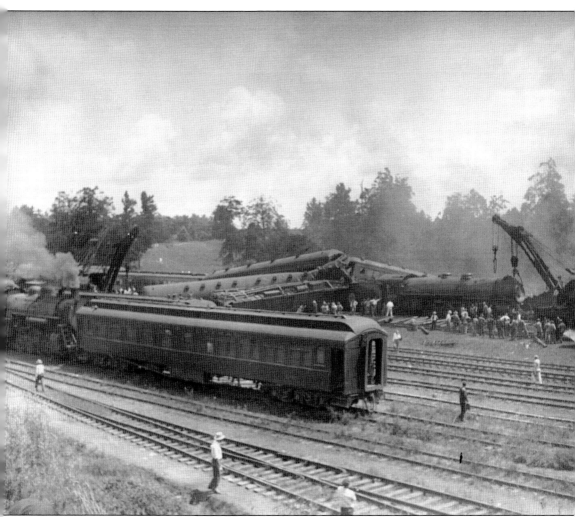

Occasionally, a wreck's cause defies belief. Such was the case on August 6, 1928, when southbound passenger train No. 3 derailed at Mounds, Illinois, killing six passengers and two crewmen. The chain of events leading to this derailment started several hours earlier. At approximately 12:15 a.m., a northbound freight pulled out of the yard at Mounds. Unbeknownst to the train's crew, a 16-foot-long section of cast-iron pipe fell off a gondola and onto the southbound main line. Then, at 2:27 a.m., southbound passenger train No. 203 struck the pipe, knocking it onto the northbound main line. Shortly after 3:00 a.m., northbound passenger train No. 16 struck the pipe. This time the pipe knocked the southbound main line out of alignment. Southbound passenger train No. 3 hit the damaged track while traveling at a speed estimated to be between 55 and 65 miles per hour. Train No. 3 derailed, and its cars struck the cars on train No. 16.

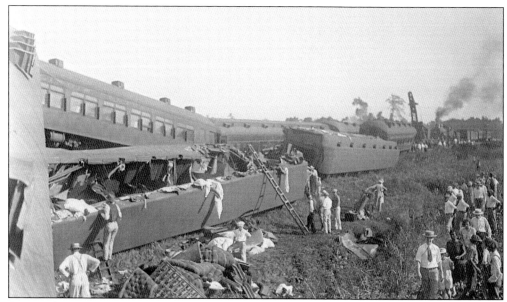

During the Mounds wreck, cars were tossed around like children's toys. Several cars were ripped open, including the car seen on this page. Although several passengers and crew members aboard train No. 16 were injured, all of the fatalities occurred aboard train No. 3. In the late 1800s and early 1900s, railroads had switched from wooden passenger cars to steel cars for safety reasons. However, as these photographs demonstrate, not even steel cars could provide much protection during a high-speed derailment.

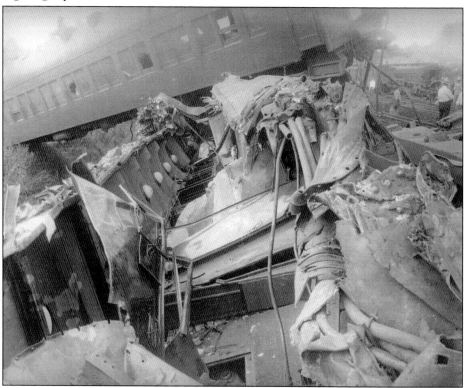

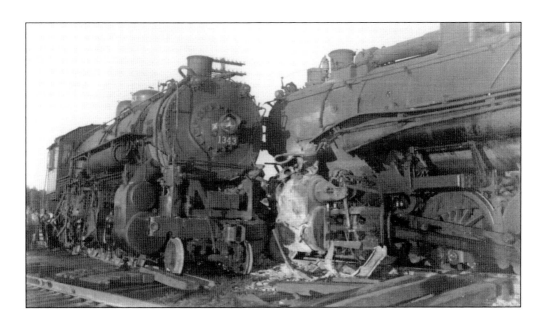

Fluker, Louisiana, about 80 miles north of New Orleans, was the site of this unusual side-swipe collision on November 2, 1940. The 2-8-2 locomotive No. 1343 ran through a switch at the end of a side track. It was then hit by a northbound train pulled by 2-8-4 No. 8007. This low-speed collision caused both locomotives to derail, yet they remained upright. The sun was beginning to set when these photographs were taken, but crews worked late into the night to clear the tracks. Damage to both locomotives was fairly minor, and within a few months, both had been repaired and put back into service. (Both, C.C. Grayson photograph.)

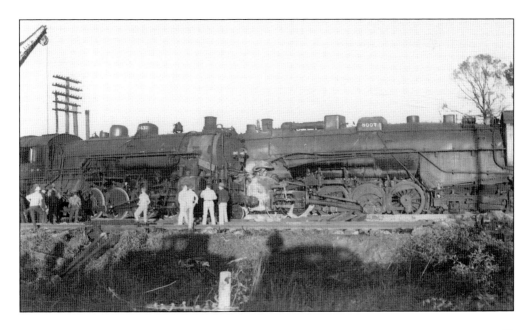

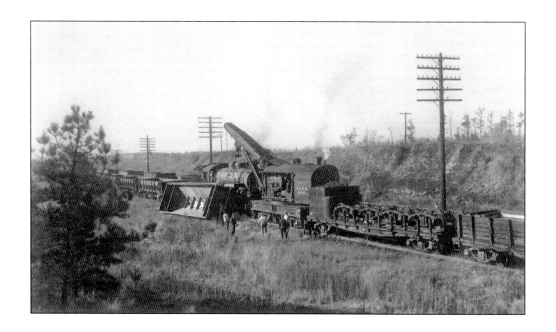

Human error caused this collision at Crystal Springs, Mississippi, on December 18, 1941. Cars used to load gravel had been switched onto a siding. One of the cars was left sticking out onto the main line and was struck by 2-8-2 locomotive No. 1395. Big hook No. X-89 was called to pick up the offending freight car and swing it out of the way so locomotive No. 1395 could be removed. Most rail accidents and near misses were followed by a formal investigation by the division superintendent. If employees were found to have violated the rules and caused a wreck, they were subject to discipline, ranging from a reprimand, suspension, or termination. (Both, C.C. Grayson photograph.)

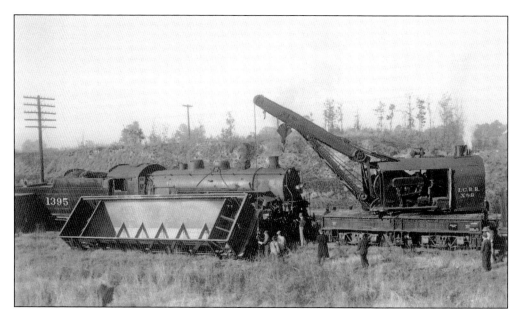

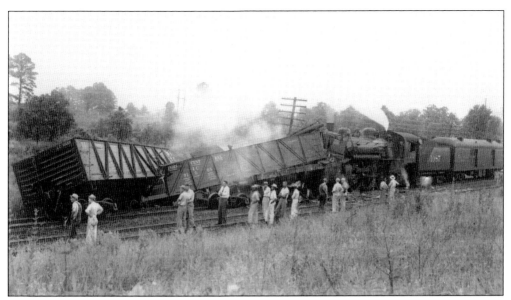

Cabooses often bring about nostalgic memories of yesteryear. Many people, though, are not aware that cabooses could be dangerous, or even deadly, to the railroaders who rode in them. The two photographs on this page graphically illustrate this danger after a passenger train rear-ended a freight train at South Jackson, Mississippi, on July 5, 1941. (C.C. Grayson photograph.)

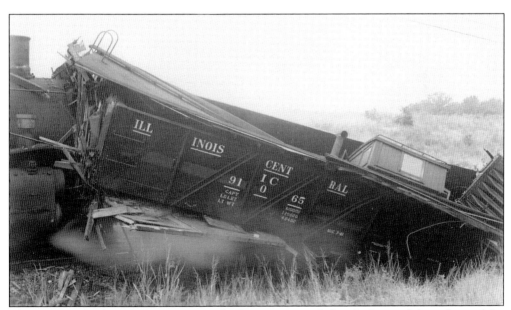

The impact split the caboose in two, and it became entangled with the gondola in front of the caboose. The roof and cupola of the caboose can be seen sticking out of the top of the gondola, while the frame of the caboose is underneath. (C.C. Grayson photograph.)

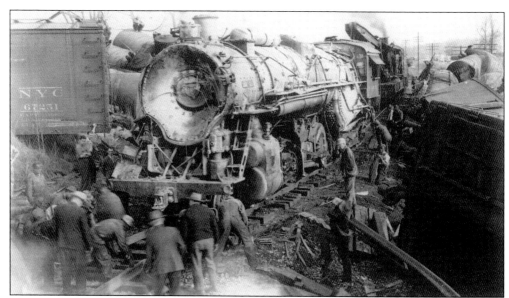

Was 2-8-4 locomotive No. 8003 cursed? This locomotive was seen on pages 30–31 after derailing in the yard at Jackson on May 3, 1941. Exactly four months earlier, on January 3, 1941, a northbound freight pulled by locomotive No. 8003 rear-ended another freight at Tinsley, Mississippi, derailing 28 cars, including 13 tankers filled with molasses. The impact smashed in the smoke box and derailed the big locomotive, although it remained upright. (C.C. Grayson photograph.)

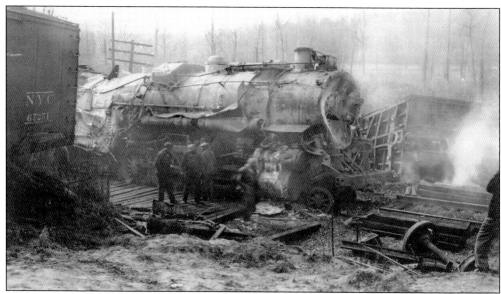

A fire broke out following the rear-end collision at Tinsley, inflicting even further damage to locomotive No. 8003 and the derailed cars. This photograph was taken on the engineer's side of the locomotive and illustrates that the running boards on the side of the locomotive melted in the heat of the fire. A boxcar to the right was still smoldering when this photograph was taken. (C.C. Grayson photograph.)

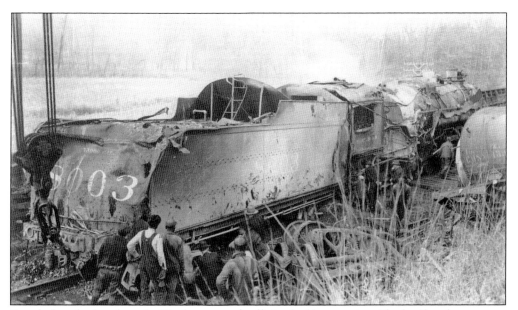

Even before the fires from the Tinsley rear-end collision had been extinguished, railroad crews were busy assessing the damage and working on a plan to rerail locomotive No. 8003. Both the tender and locomotive sustained heavy damage. Wreckers X-89 from Jackson and X-92 from McComb, Mississippi, were both called to the wreck site. (C.C. Grayson photograph.)

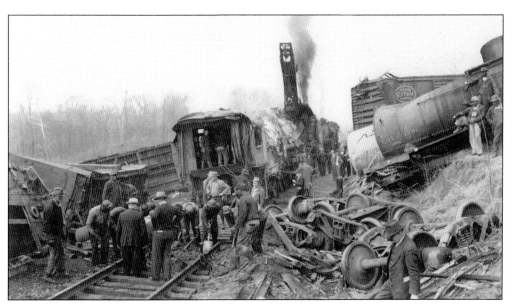

Locomotive No. 8003's tender has been pulled out of the way, and crews are working to rerail the big locomotive. In a few hours, it will be back on the rails, the tracks will be cleared, and trains will be running again. (C.C. Grayson photograph.)

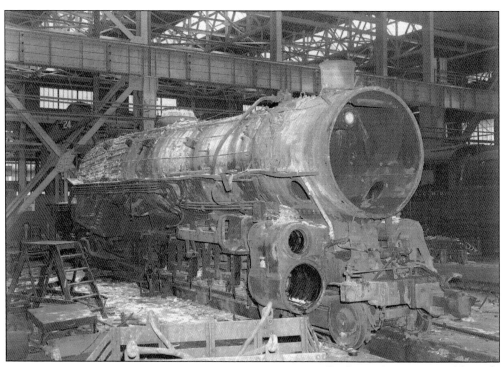

On June 15, 1948, a northbound freight train rear-ended another northbound freight at Rives, Tennessee. Two tank cars filled with gasoline were split apart, starting a fire that took several hours to extinguish. The second train was pulled by 4-8-2 locomotive No. 2351. Several weeks after the accident, the heavily damaged locomotive is seen here being repaired at IC's back shop in Paducah. (Sam Harrison collection.)

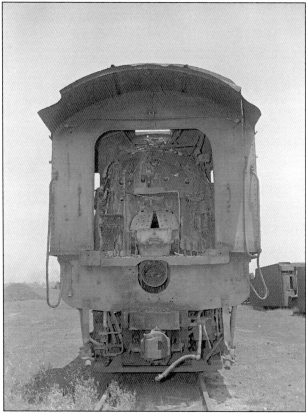

Mikado 2-8-2 No. 1350, which was pulling the lead train in the Rives wreck, was also heavily damaged and sent to Paducah for repairs. The fire-ravaged locomotive was photographed in storage while awaiting repair. In this view, the locomotive has been separated from the tender, providing a rare look at the back end of the cab. No. 1350 was also repaired and put back in service. (Sam Harrison collection.)

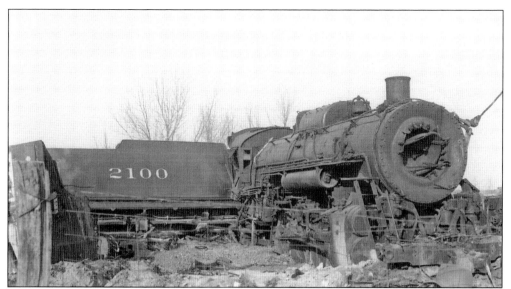

Allenville, Illinois, is a small town roughly 15 miles northeast of Mattoon. During the predawn hours of October 25, 1952, the peace and tranquility was shattered when an eastbound freight rear-ended another eastbound freight that had stopped to switch at a local industry. Three crewmen were injured, including a brakeman who received second- and third-degree burns from steam escaping from a ruptured pipe on 2-8-2 locomotive No. 2100. (Gerald Carson collection.)

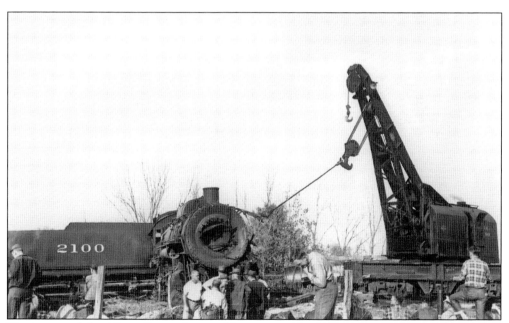

The impact of the Allenville wreck caused locomotive No. 2100 and its tender to jackknife. Big hook No. X-90, stationed at Mattoon, was called to the scene and is seen here during the rerailing process. After the wreck, No. 2100 was repaired and served the IC until 1956, when it was sold for scrap. (Gerald Carson collection.)

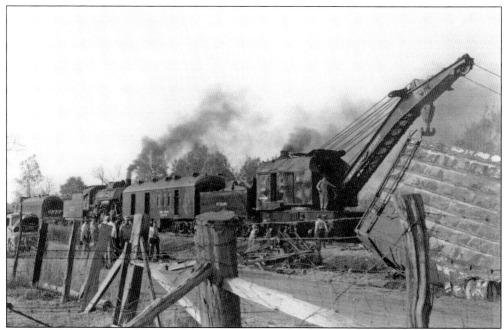

Three freight cars also jumped the tracks during the Allenville wreck, including a car loaded with paper. During the rerailing process, an acetylene torch was used to free this car from the others. Unfortunately, the torch set the paper on fire, and both the car and its cargo were destroyed. Here, the burning car has been shoved aside so big hook X-98 can help rerail locomotive No. 2100. (William Raia collection.)

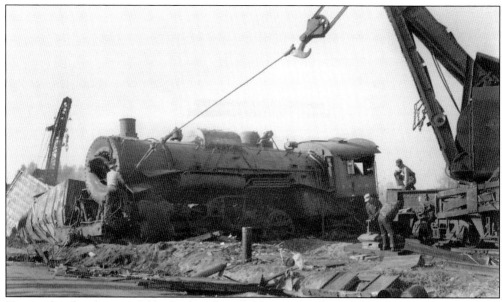

Nerves of steel and a powerful big hook with a solid footing are all needed to clear an accident. Three men can be seen at right stacking large blocks of wood. These will go underneath the outriggers, those heavy steel beams sticking out from a crane. Without the outriggers and a solid base to rest on, the big hook might flip over. (Paul Slager photograph; William Raia collection.)

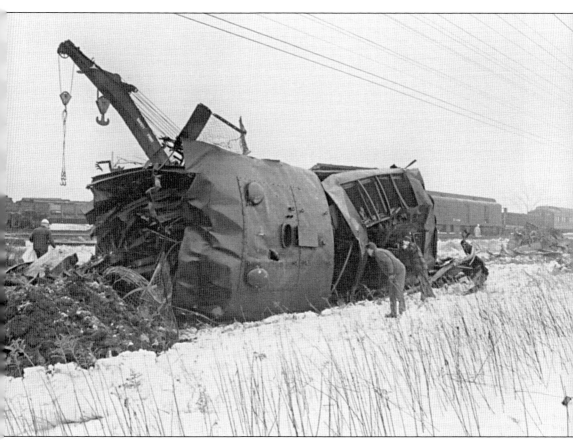

Safety can never be taken for granted. That lesson was learned the hard way in 1969 when 10 employees were killed and 20 other employees and 34 passengers were injured in three major collisions. The first collision took place at 12:39 a.m. on January 17 at Indian Oaks, Illinois. Northbound Extra 9192 freight ran a red (stop) signal at a junction where the three-track main line narrows to two tracks. The freight train then collided with passenger train No. 25, the southbound Campus, which was traveling approximately 70 miles per hour. The engineer and fireman of the passenger train were killed along with the engineer of the freight train.

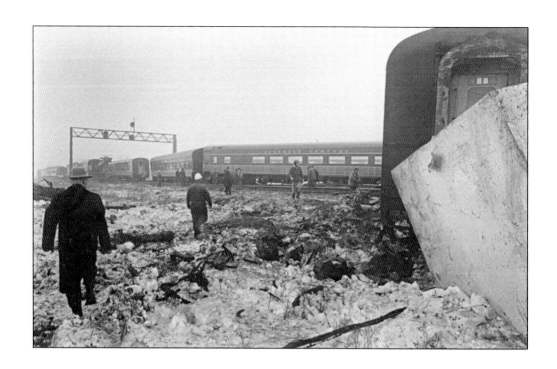

In addition to the terrible human toll, there was considerable physical damage inflicted during the 1969 collision at Indian Oaks. All three locomotives on the passenger train were damaged beyond repair. Additionally, all 13 cars on the passenger train derailed, and five were destroyed. Two locomotives pulling the freight train were destroyed, and the third had to be extensively rebuilt before returning to service. Seven cars on the freight train derailed, and four were destroyed. Total damage to tracks and equipment was estimated at $667,850. The second major collision on the IC during 1969 occurred on July 7 near McManus, Louisiana. This wreck (which is not covered in this book) was a head-on collision between two freight trains, each traveling approximately 40 miles per hour. Four crewmen were killed, and six other crewmen were injured.

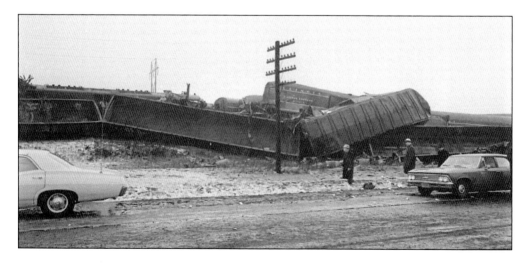

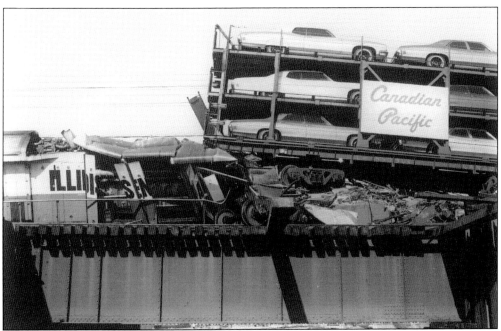

The third major collision of 1969 took place at Riverdale, Illinois, on September 26. Around 4:00 a.m., a transfer run had left IC's yard in Harvey, Illinois, with freight cars to be dropped off in a nearby yard. At 4:30 a.m., the transfer run stopped to align a switch. The transfer run was then rear-ended by Extra 5055 North, a loaded 128-car coal train. The coal train ripped through the caboose and the last five cars of the transfer run. When the coal train finally came to a halt, its lead locomotive was wedged underneath a tri-level automobile carrier (above). The coal train's two other locomotives also derailed (below). But more importantly, the engineer and head brakeman of the coal train were killed along with the rear brakeman of the transfer run. (Both, Lee Hastman photograph; William Raia collection.)

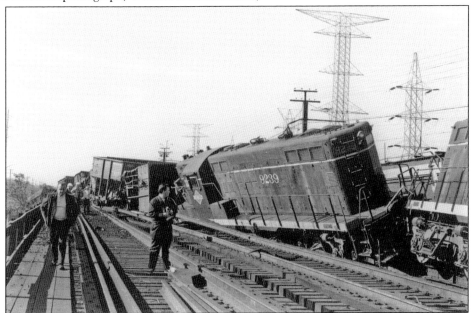

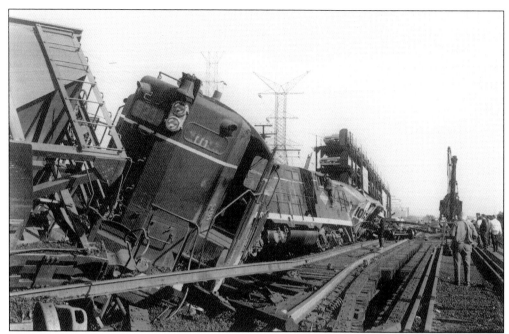

The Riverdale accident was investigated by the Federal Railroad Administration (FRA), which at the time was responsible for investigating major railroad accidents. The FRA's report, released on January 18, 1971, stated the wreck was due to "Engineer and front brakeman of the [coal] train falling asleep due to fatigue and the effects of alcohol, resulting in the train passing stop-signals and colliding with the [transfer run]." (Lee Hastman photograph; William Raia collection.)

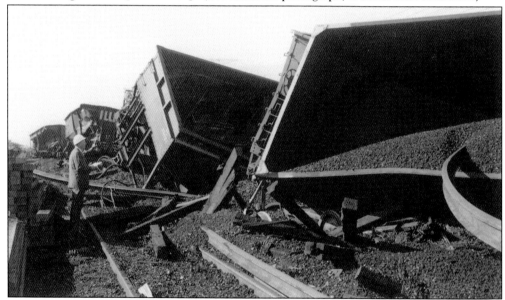

Tragically, the Riverdale collision was neither the first nor the last railroad accident blamed on alcohol use and/or fatigue. Current federal regulations state train crews can work a maximum of 12 hours and then must have at least eight hours of rest before their next run. This cycle of 12 hours on, 8 hours off can go on indefinitely and often does not provide enough rest. (Lee Hastman photograph; William Raia collection.)

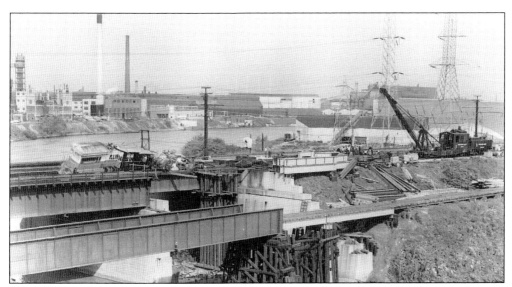

The 1969 Riverdale collision took place on a bridge spanning the Little Calumet River. At the time of the collision, the bridge was being rebuilt and suffered considerable damage. The collision also severed IC's electrified commuter route into downtown Chicago, but IC crews worked quickly to clean up the devastation. When this photograph was taken on October 1, only the lead locomotive from the coal train remained. (Sam Harrison collection.)

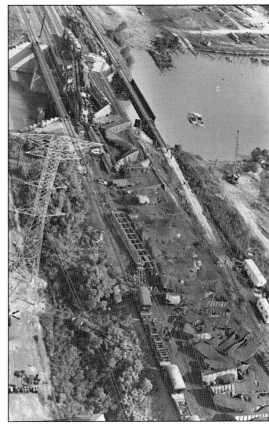

This aerial photograph shows the scope of the 1969 Riverdale collision. The transfer run's caboose can barely be seen at lower left, while the locomotives of the coal train can be seen at top. Sixty-six loaded coal hoppers derailed. The coal train's momentum caused most of these cars to jackknife, and they landed in a massive pile. (Sam Harrison collection.)

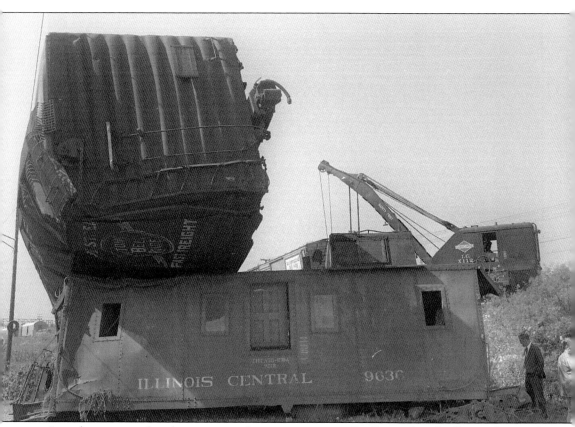

Less than a year after the tragic accident seen on pages 61–63, another deadly accident took place on the IC in Riverdale, Illinois. At 10:30 p.m. on September 8, 1970, a switch crew went on duty at IC's Markham Yard in Homewood. Their task was to head north along the main line switching freight cars at industries along the way. The switch crew normally left the yard with the locomotive in the lead. However, normal operations had been disrupted by the Labor Day holiday (which was the previous day), and the train left the yard with the caboose in the lead. At approximately 11:08 p.m., the IC switch crew collided with Indiana Harbor Belt (IHB) NW2 locomotive No. 8717 in Riverdale. The IHB locomotive was pulling a transfer run headed to IC's Markham Yard with freight cars to be interchanged. During the collision, the IC caboose rode up and over IHB No. 8717. The IC caboose then rolled down an embankment and came to rest with a boxcar sitting on its roof. (Sam Harrison collection.)

There were two fatalities and two serious injuries in the 1970 collision at Riverdale. The IC conductor died soon after the wreck, while the rear flagman was seriously injured. Both men had been riding in the caboose. Aboard the IHB locomotive, the engineer was killed and the head brakeman was seriously injured. Both the IC caboose and IHB locomotive No. 8717 sustained heavy damage. The photograph at right shows the end of the caboose with a boxcar (loaded with lumber) sitting on top of it. During the collision, the cab of IHB locomotive No. 8717 was sheared off. Part of the cab was thrown into the weeds, where it was photographed with the railroad's emblem and locomotive number partially legible. (Both, Sam Harrison collection.)

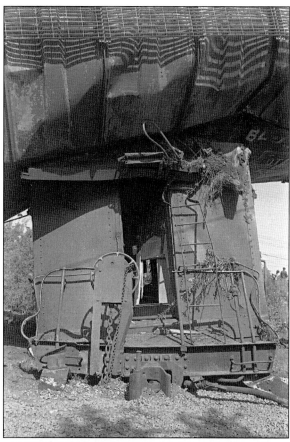

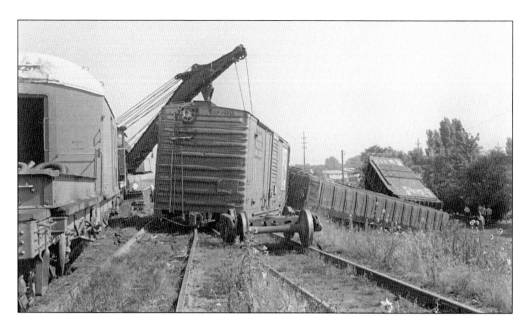

After the 1970 wreck at Riverdale, a big hook was rushed to the scene from Markham Yard, the same yard where the IC switch crew had originated. When these photographs were taken in mid-morning, the wreck crew had already been at work for several hours. Sadly, during the 1970s, IC's wreck gangs were called out numerous times. Track maintenance all across the system was cut back to save money, which was accompanied by an increase in the number of wrecks, some of them quite spectacular. This trend accelerated after the IC merged with the Gulf Mobile & Ohio Railroad on August 10, 1972, to form the Illinois Central Gulf.

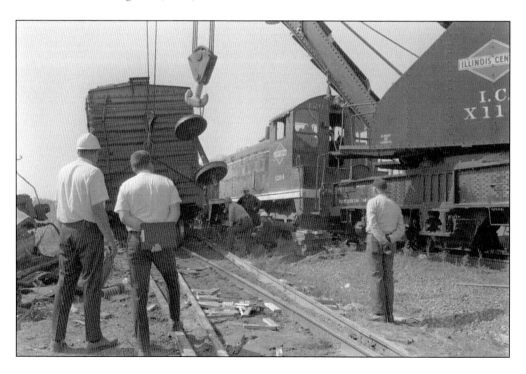

Four

FLOODS

Throughout much of its territory, the IC ran in close proximity to several major rivers. In the northern half of the system, the road followed, or crossed, the Mississippi, Missouri, Illinois, Tennessee, and Cumberland Rivers. Then, on the southern half of the system, the road ran near the Mississippi (again) and Red Rivers. These rivers helped nourish agricultural lands, which supplied the IC with considerable traffic.

However, running near these rivers was somewhat of a double-edged sword. When the rivers flooded, as they tended to on a regular basis, the IC was hit hard. Trains had to be delayed or detoured, and track repairs were needed once the floodwaters receded. Occasionally, the tracks were raised or even permanently rerouted to prevent future disruptions from floods.

Although the railroad was hit hard by the Mississippi River floods of 1912 and 1927 and the Ohio River flood of 1937, the railroad's management and employees found ways to help flood refugees. The Red Cross and other relief agencies worked with the IC to transport many flood refugees to distant cities, and empty boxcars were made available to serve as temporary housing for those who stayed behind.

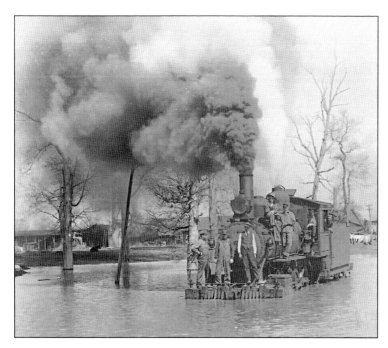

Dyersburg, Tennessee, is approximately 10 miles east of the Mississippi River. However, when "Ol' Man River" goes on a rampage, the city is not immune to its flooding. An IC company photographer caught 2-6-0 No. 1858 wading through the floodwaters at Dyersburg on April 2, 1912. Steam locomotives are capable of wading floodwaters like these as long as the water does not reach the firebox.

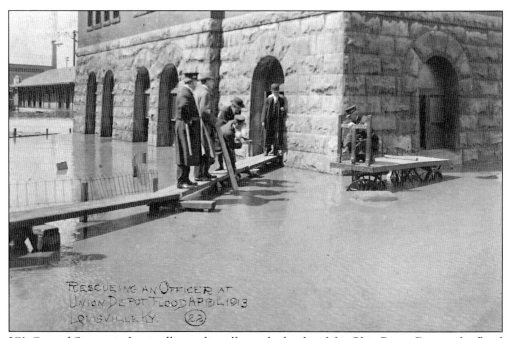

IC's Central Station in Louisville was literally on the banks of the Ohio River. During the flood of 1913, the waters jumped approximately four feet in one night, stranding several people inside. Here, an impromptu rescue is under way to save a railroad police officer who apparently did not want to wade through the floodwaters.

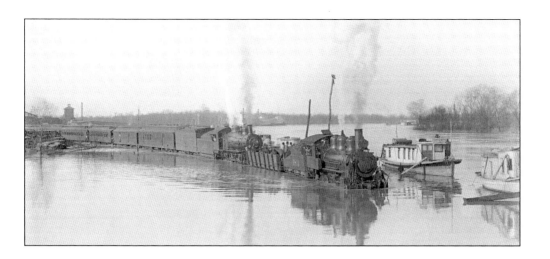

In January and February 1918, the Ohio and Mississippi Rivers were hit by massive flooding. The IC dispatched company photographer J.K. Melton to Memphis to document the damage. Melton photographed a passenger train wading through the floodwaters on February 5 under the watchful eye of numerous railroad personnel. Two locomotives have been assigned to the train, lest one have trouble and strand a trainload of passengers. A look at the rear of the train (below) reveals that an office car is bringing up the markers. Memphis was a vitally important station along the IC, and "company brass" made certain the trains keep running.

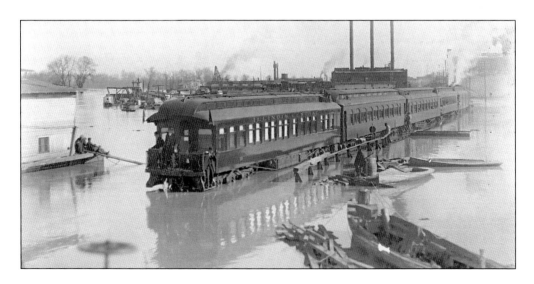

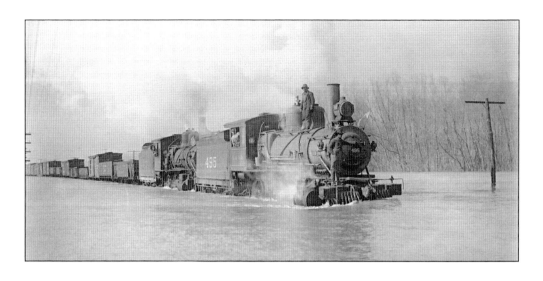

Both photographs on this page were taken by IC company photographer J.K. Melton at Memphis on February 5, 1918. The above photograph shows a freight train treading gingerly through the floodwaters. Two men are on the front of the locomotive to watch out for logs and other debris that could stop the train. Railroads, of course, are not the only victims of floods and natural disasters. The family below has turned a pair of boxcars into their temporary home. Racism often reared its ugly head during natural disasters in the South. White families were more likely to be given shelter in Red Cross camps and receive public assistance, while black families often had to improvise and find any type of shelter, often a simple tent pitched on a levee.

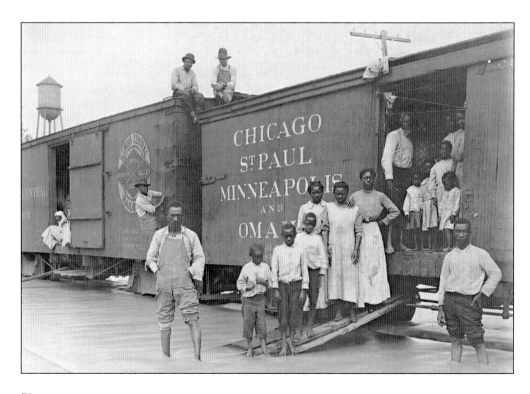

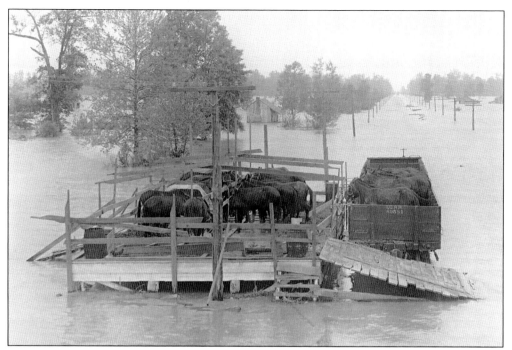

The date and location were not stamped on this photograph, but it is believed to have been taken by IC company photographer J.K. Melton in early February 1918 around Memphis. A compassionate train crew has left a gondola at this loading dock so local farmers will have a place to shelter their mules and horses during the flood.

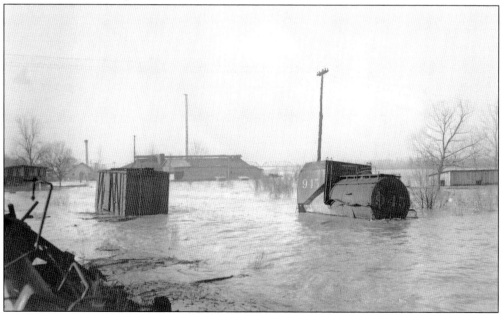

In 1937, the Ohio River and its tributaries experienced flooding of historic proportions. The Mississippi River also flooded that year, but many people seem to have forgotten about that. C.W. Witbeck visited the IC's Vicksburg, Mississippi, yard on February 21, 1937, and captured this view of a boxcar at left and the tender of a steam locomotive at right.

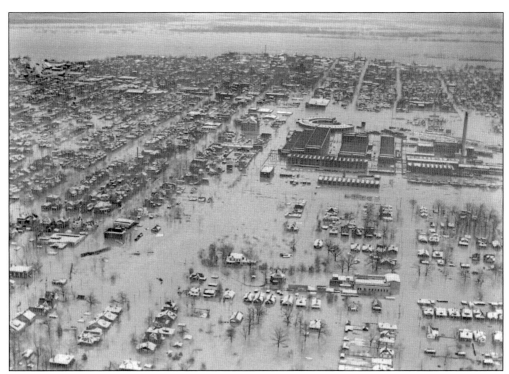

The disastrous Ohio River flood of 1937 began on an ominous note. Many towns received rain every day during January. At first, forecasters were not too worried about flooding; however, that changed by mid-January, and they began ordering everyone to evacuate towns along the river. On February 2, the flood gauge at Paducah reached an all-time high of 60.6 feet, more than six feet above the previous flood stage record. This aerial photograph was taken above Paducah in late January 1937 and shows the IC's locomotive shops near center. In the photograph below, taken at Cairo, Illinois, crews are busy unloading Coast Guard boats that had been shipped by rail from East Coast cities. During 1937, the IC was forced to completely halt service to Louisville, Paducah, Cairo, and Memphis for periods ranging from five days to two weeks.

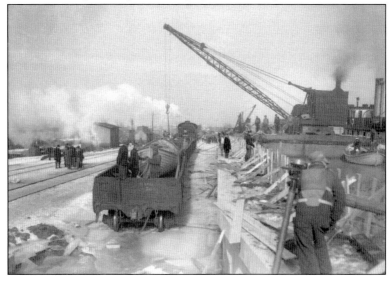

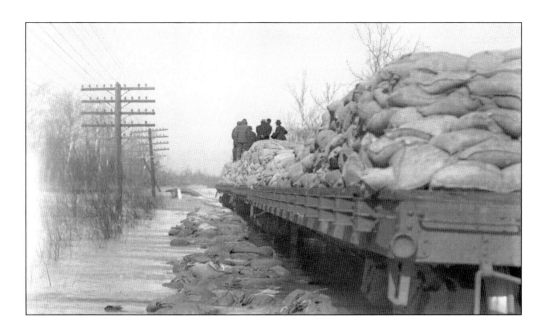

Between East Cairo and Wickliffe, Kentucky, the IC's main line runs through a swampy area that is often flooded by both the Ohio and Mississippi Rivers (the two rivers converge at Cairo). This line had been shut down in late January 1937 by rising floodwaters. As the waters receded, a track crew left Wickliffe on February 12 headed towards East Cairo to inspect the track. At Milepost 368 (measured from Chicago), the crew discovered the track had been completely washed out. Approximately 3,200 feet of track was washed away along this section.

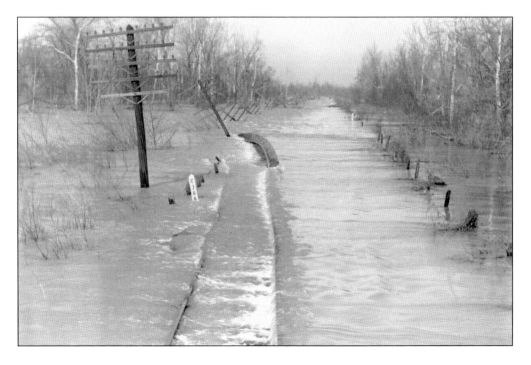

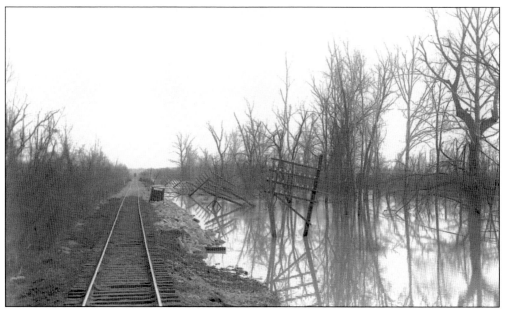

IC's determination to reopen its line after the 1937 flood was nearly as strong as the floodwaters themselves. This photograph was taken on February 15 at nearly the same spot as the lower photograph on page 73 but looking in the opposite direction. By this time, the floodwaters had fully receded from the tracks, allowing a track gang to perform temporary repairs so train traffic could resume.

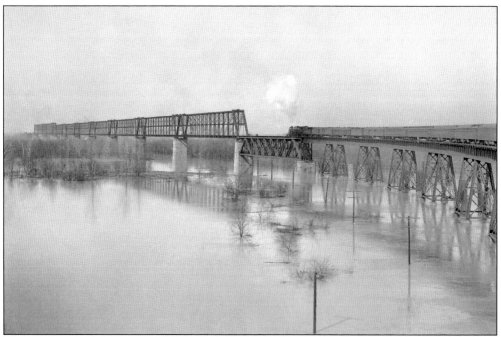

A northbound IC passenger train climbs the long trestle leading to the Ohio River Bridge at Cairo on February 15. This was one of the first passenger trains to cross the bridge, which was shut down for two weeks due to floodwaters. The bridge itself stayed above the floodwaters, but the approach tracks on both sides of the river were covered with up to five feet of water.

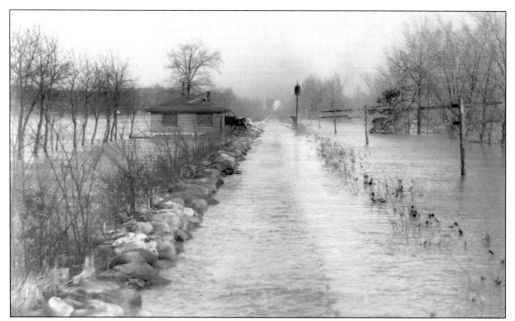

Floodwaters extended far from the Ohio River during the 1937 flood. This photograph was taken near Reevesville, Illinois, on February 11, 1937. Reevesville is approximately 10 miles north of the Ohio River, but the region's flat terrain made the town vulnerable to flooding.

During floods, it is not uncommon for railroads to park locomotives or cars on bridges. The idea is to add weight to the bridges to keep them from washing away. A company photographer captured this scene of boxcars parked on the Cache River near Ullin, Illinois, on February 11, 1937.

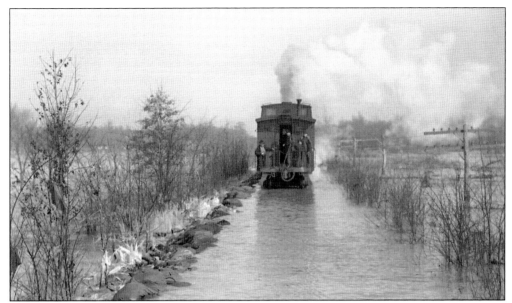

This photograph is dated February 11, 1937, and the location is simply marked "southern Illinois." A short train is wading through floodwaters, which are about a foot above the rails. The flood prompted the IC to elevate several miles of track in southern Illinois and western Kentucky with the goal of preventing future flood-related closures.

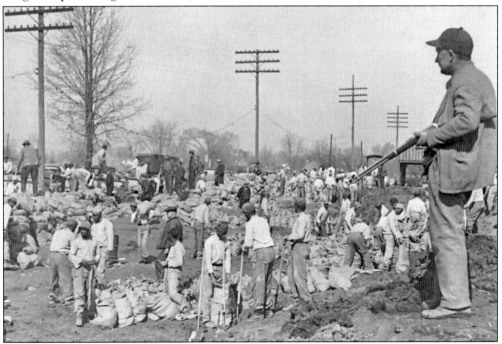

Hundreds of inmates were put to work during the 1937 flood, filling sand bags, evacuating families, building boats, and performing countless other types of manual jobs. This photograph is simply labeled "1937 near Metropolis, Illinois." An armed guard stands watch over the work gang. The gun is for more than just show. If an inmate tried to run, he knew the guard had orders to shoot him dead.

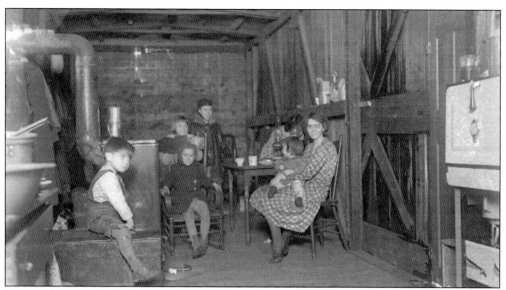

During the 1937 flood, several relief agencies offered free transportation from cities and towns along the Ohio River to inland cities away from the flood zone. Those who chose to stay faced many challenges, including scarce rations and water, lack of indoor and outdoor plumbing, and, most importantly, shelter from the floodwaters and the cold weather. These two families photographed at Ballard Junction, Kentucky (near Wickliffe), on January 26, 1937, have equipped their temporary homes with cooking stoves and furniture. The stoves helped cook food and keep families warm, but they were also deadly. Approximately 400 people died during the flood (the exact number varies according to the source). Many of those deaths were due to asphyxiation caused by stoves that were not properly ventilated.

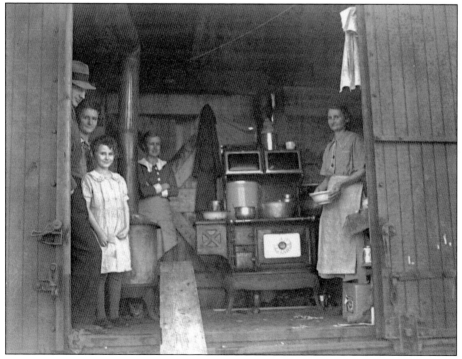

In many parts of the Ohio River Valley, the flood of 1937 was accompanied by freezing weather. At Cairo, a long string of boxcars was used for temporary shelter. Those who dared to go outside had to brave the icy ground and bone-chilling winds.

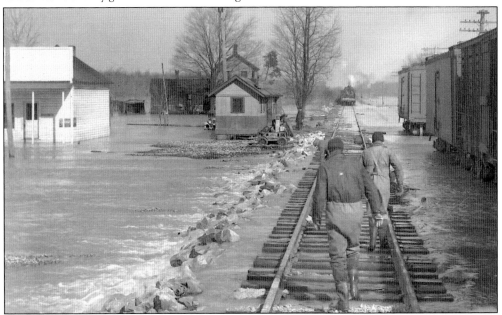

The floodwaters are quickly receding as a track gang works its way along one of IC's lines in southern Illinois on February 11, 1937. During the flood, countless IC employees sent their families to stay with distant friends and family but stayed behind to work on the railroad. Their commitment and hard work made it possible for the IC to resume normal operations soon after the floodwaters receded.

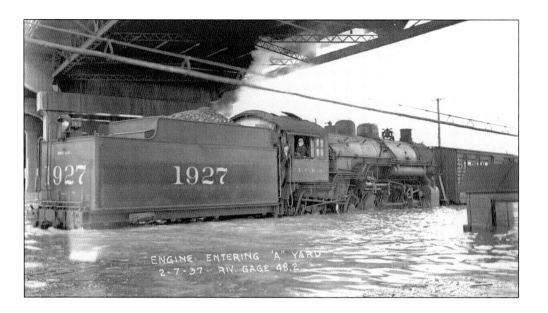

As the waters of the 1937 Ohio River flood flowed south, towns and cities along the Mississippi River also experienced major flooding. At Memphis, all IC routes entering the city were covered by water. Trains were able to wade through some of the water, but a handful of routes had to be shut down entirely. The passenger main line along the riverfront was shut down on February 4 and did not reopen until February 17. Train movements at IC's major freight yard in Memphis, Nonconnah Yard, were greatly hampered, but the yard remained open. Above, a switch crew wades through deep floodwaters on February 7, 1937. The water would rise approximately another foot before finally receding. At Poplar Street (below), the floodwaters nearly covered the foundation of the station, which had been torn down several years earlier.

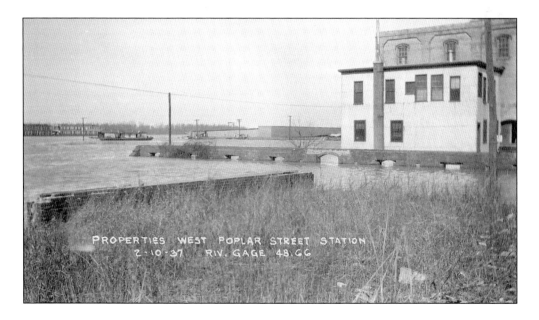

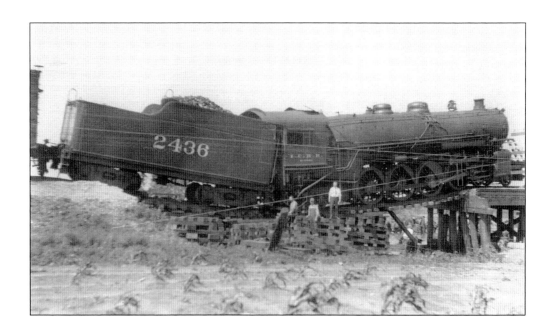

Although no information was written on these prints, it is believed these photographs were taken around 1940 in Iowa. One end of the trestle was apparently washed out during a flood, and the locomotive crew, unaware of the damage, continued onto the damaged trestle. Rerailing the big 4-8-2 "Mountain" was made difficult by the fact that a wrecking crane could not reach the locomotive cab; it sat where the sag in the track was greatest. Another photograph (not included here) shows that crews used heavy hydraulic jacks to lift both the locomotive and tender so more wooden timbers could be placed underneath. Once the track was level, the locomotive and tender were pulled off the trestle.

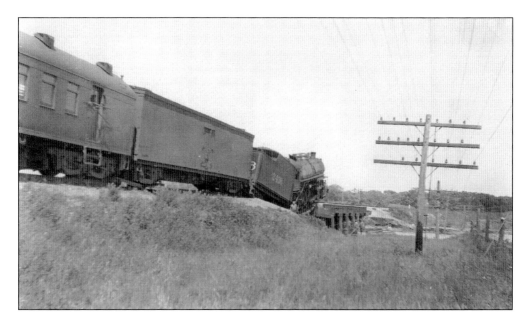

Five

GRADE CROSSING COLLISIONS

Even before the invention of the automobile, grade crossing collisions have been a major concern of the railroad industry. Back in horse-and-buggy days, it was not uncommon for horses to be easily spooked when a steam locomotive blew its whistle at a grade crossing. Horses were known to run away from crossings and even occasionally run in the path of an oncoming train.

With the advent of the automobile, railroads faced a new challenge: warning drivers of the "horseless carriage" not to pull in front of trains. Keeping motorists off the tracks probably seemed an impossible task at times. According to the US Department of Transportation, in 1920 there were 1,273 fatalities at railroad grade crossings, and by 1928, the number of fatalities had increased to 2,165. The Great Depression brought about a sharp decline in the number of fatalities, but the number of accidents, and fatalities, increased as the economy improved.

The IC tried diligently to keep motorists off the tracks. Considerable time and money was spent to mark grade crossings. During the early 1900s, watchmen were stationed at busier grade crossings. In time, these were replaced by automated gates with bells and lights. There were also grassroots efforts to educate drivers. Despite this, tragic accidents continued to happen, such as the collision of the City of New Orleans with a gasoline tanker in Loda, Illinois, in January 1970 (see pages 90–92).

In the early 1970s, the number of grade crossing accidents began to steadily fall due in large part to Operation Lifesaver. This program uses volunteers to give safety lessons to students, civic groups, and at public events such as fairs. More information about this program can be found at oli.org.

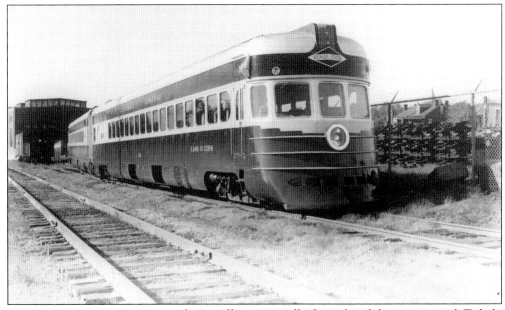

Most passenger trains were money-losing affairs, especially those that did not carry mail. To help reduce some of those losses, on October 28, 1941, the IC inaugurated the Land O' Corn between Chicago and Waterloo, Iowa. The Land O' Corn consisted of two self-propelled motorcars coupled together. The cars were built by American Car & Foundry (AC&F) at its plant in St. Louis, Missouri. (AC&F publicity photograph.)

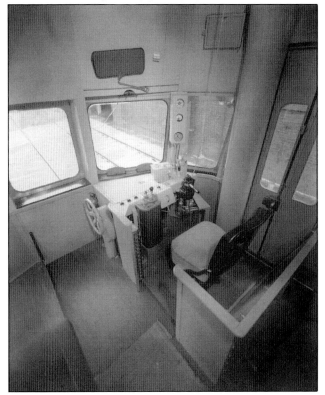

The lead car of the Land O' Corn had a small control stand for the engineer. AC&F had considerable experience building cars for interurbans and street railways, and this slim control stand is reminiscent of those cars. To help reduce weight, there was no dividing wall between the engineer's compartment and the rest of the car. Also, there was minimal protection against grade crossing collisions. (AC&F publicity photograph.)

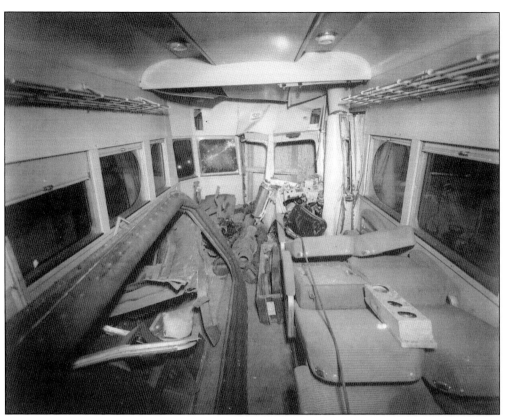

The Land O' Corn's limited protection against grade crossing accidents became tragically apparent on February 18, 1942. While traveling at an estimated 70 miles per hour, the train hit a truck hauling beer. The impact caved in the front of the lead motorcar, killing engineer D.H. Sullivan. As with most major rail accidents, the Interstate Commerce Commission (ICC) investigated the collision. According to ICC report 2570, released on August 31, 1942, investigators discovered the signals were working properly and that the driver of the beer truck had driven around a car stopped at the grade crossing. Investigators concluded their report with the statement, "It is found that this accident was caused by a motor truck being driven upon a highway grade crossing immediately in front of an approaching train."

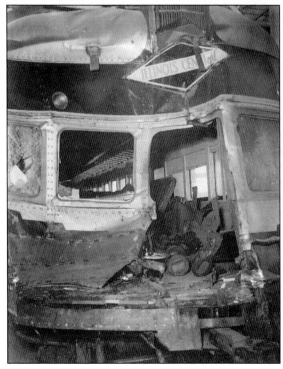

Like many major cities, Jackson, Tennessee, has numerous grade crossings. Visibility at many of these crossings is limited due to buildings, fences, billboards, trees, etc. This is a common problem in many cities, as areas around railroad tracks are developed for commercial or residential purposes. In 1949, the IC documented several of the crossings with limited visibility. Both photographs are believed to have been taken north of the downtown district. These photographs also demonstrate two different types of grade crossing protection. The grade crossing below has simple cross bars and flashing lights, while the crossing above has flashing lights and gates. (Both, Sam Harrison collection.)

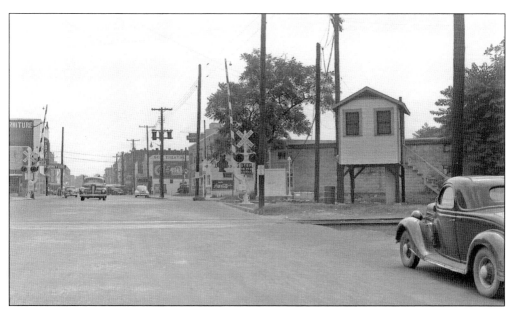

In addition to the automated gates, the IC also had at least one manned grade crossing shack in Jackson, Tennessee, seen at right in this photograph taken in 1949. This small shack was similar to the countless grade crossing buildings constructed across the country by different railroads. Advances in technology allowed the IC to eventually eliminate manned grade crossing shacks. (Sam Harrison collection.)

The date "July 30, 1948" was written on the back of this print, and it is believed the photograph was taken in Birmingham, Alabama, but otherwise no information about this wreck is available. Rail accidents of any kind tend to draw a crowd of curious spectators. Curiosity often outweighed safety, as the well-dressed man stepping over the tow truck cable demonstrates.

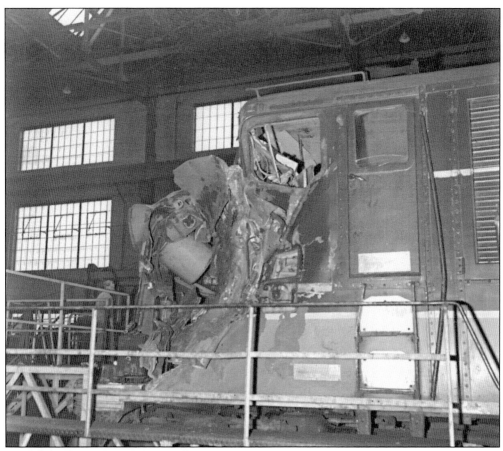

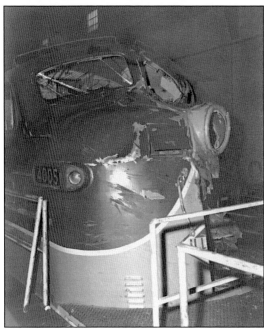

There were no injuries when the northbound City of New Orleans hit a semitrailer at Onarga, Illinois, on November 21, 1951. However, the lead locomotive, E7A No. 4005, suffered considerable nose damage. These two photographs were taken inside IC's Burnside Shops on the south side of Chicago. Despite the heavy damage, the locomotive was repaired and put back in service. As for the truck that No. 4005 hit, its steel frame was hurled about 100 feet and was twisted around a tree. Several days passed before workers could remove it. (Both, Sam Harrison collection.)

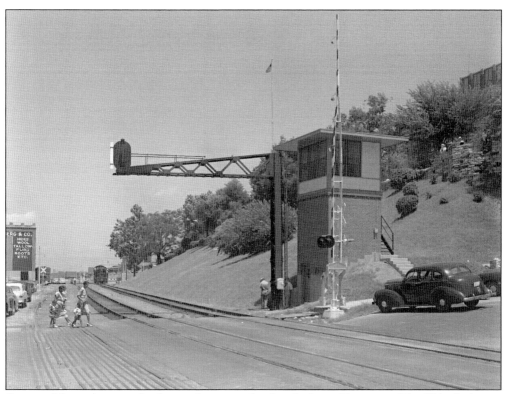

On page 85 is a photograph of a guard crossing shack in Jackson, Tennessee. The IC had a larger, more elaborate tower in Memphis at the intersection of Riverside Drive and Court Avenue. This tower controlled the signals at four grade crossings, including Union, Monroe, Court, and Jefferson Avenues. Both photographs were taken in mid-1951 shortly after the tower was completed. The above photograph is looking north at high noon. A family crosses the tracks shortly after a Union Railway of Memphis yard switcher had cleared the crossing. Below, the operator poses next to the control stand. (Both, Chris Thompson collection.)

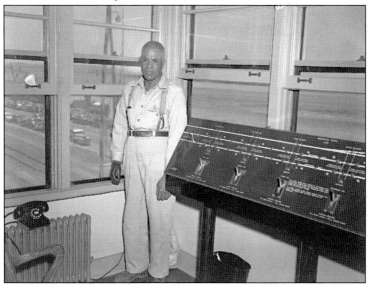

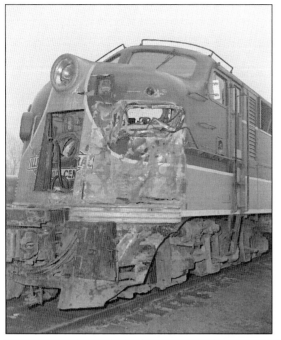

"Burnside Shops, March, 1952. Locomotive No. 4000 after grade crossing accident" is the brief note written on the sleeve for these negatives. It is the only information available for these photographs. IC's heavy repair shops were located in Paducah. However, at the time of this accident, they were not set up for heavy diesel repairs. The Burnside Shops on the south side of Chicago did have the necessary machinery, and thus, locomotive No. 4000 was repaired there. One has to wonder if locomotive No. 4000 was jinxed. It was purchased in 1947 to replace an older locomotive that had been wrecked. In 1954, it was renumbered to 4004 and in 1969 was destroyed in a wreck at Indian Oaks, Illinois (pages 59–60). (Both, Sam Harrison collection.)

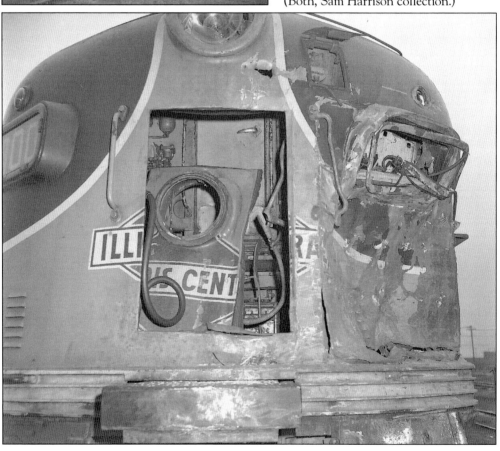

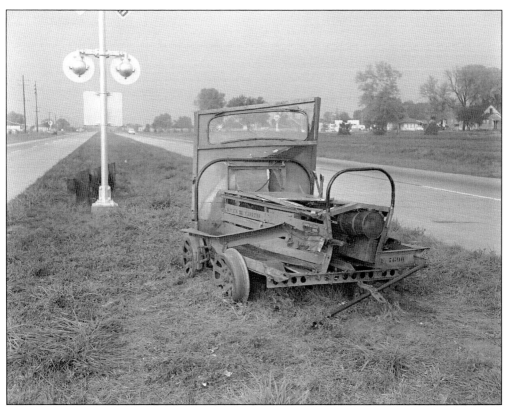

Grade crossings can be dangerous for all types of rail workers, not just train crews. Both photographs on this page were taken on October 25, 1954, shortly after a track speeder and a trailer were struck by a car at the US 66 grade crossing near Lincoln, Illinois. The track speeder and trailer were both destroyed and five track workers were hurt during the collision, which happened during heavy fog. Although the crossing was protected by bells and lights, the track speeder was too light to activate the lights. (Both, Sam Harrison collection.)

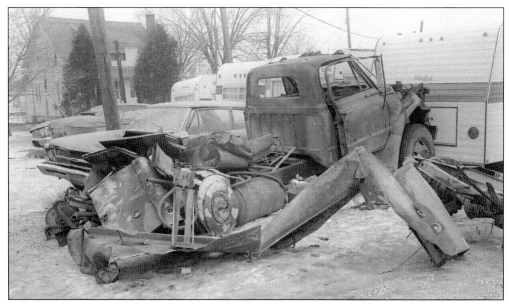

Locomotive crews are fearful of any type of grade crossing collision, but a crash with a tanker hauling flammable liquids is even more terrifying. The southbound City of New Orleans passenger train was cruising through Loda, Illinois, on January 24, 1970, when it struck a gasoline tanker at the South Second Street crossing. At the time, the train was traveling 79 miles per hour, its maximum authorized speed. National Transportation Safety Board (NTSB) report RHR-71-1 detailed what happened next: "The tank of the truck was split open, spilling the gasoline which exploded and caught fire. The burning gasoline covered the exterior of the locomotive unit and entered the control compartment through the nose door, damaged nose, and other openings." These two photographs of the destroyed tanker truck were taken on January 27, 1970. (Both, Sam Harrison collection.)

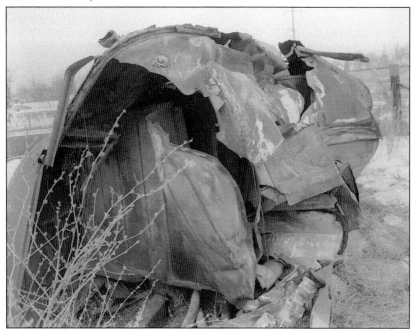

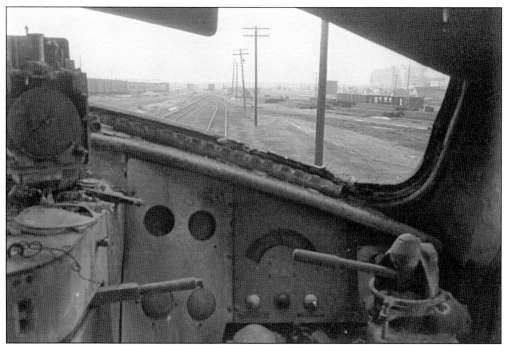

At the time of the Loda collision, the cab of the lead locomotive was occupied by engineer Thomas Clarke Jr.; James Zagorski, an IC transportation engineer who was serving as the train's fireman; and Newell Brown, assistant to IC president Alan Boyd. According to the NTSB report, all three men jumped from the cab after the collision while the train was still in motion. Zagorski died at the scene along with the truck's driver, Robert Newby. Brown died later that day, and Clarke died on January 27. Both photographs of the burned cab were taken January 27, 1970, at IC's yard in Champaign. (Both, Sam Harrison collection.)

The regular fireman for the City of New Orleans was in the engine compartment during the Loda grade crossing tending to an electrical issue. Flaming gasoline made its way into the engine compartment, as seen here. He fled the locomotive through the rear door and escaped injury. (Sam Harrison collection.)

This side view shows that flaming gasoline covered the side of lead locomotive E8A No. 4019 after the Loda grade crossing collision. The second and third locomotives pulling the train also received fire damage to the exterior along with the first three passenger cars. No passengers were injured during the collision. (Sam Harrison collection.)

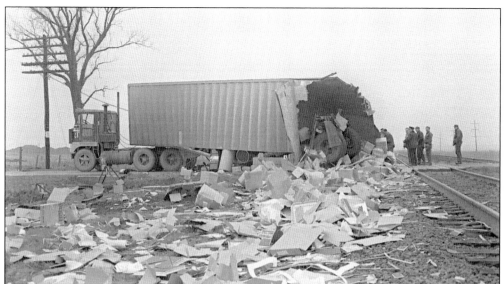

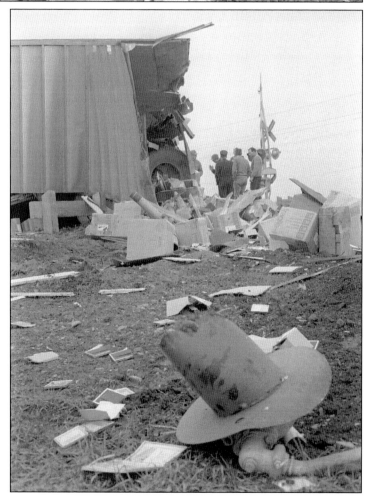

On the back of these two prints is the notation "Kankakee [Ill.], 3-4-70," but otherwise no information is available. During a collision with an unidentified passenger train, this semitrailer was split open, spilling its cargo along the right-of-way. The rear axles of the trailer have been bent upward and into the trailer body, and the floor of the trailer has collapsed, allowing at least two barrels to fall to the ground. The violent collision also took its toll on the grade crossing signals. One of the crossing arms was knocked down, and the light was thrown about 25 feet from the crossing. (Both, Sam Harrison collection.)

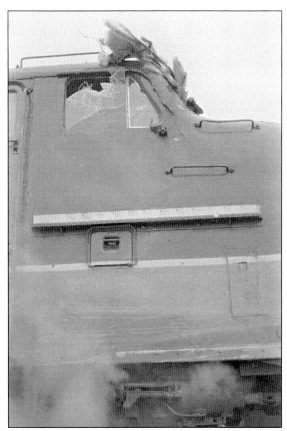

These two photographs illustrate some of the damage to the locomotive involved in the March 4, 1970, grade crossing at Kankakee, Illinois. The front and side windows on the engineer's side of the cab have been broken. It appears that some of the metal framework and insulation from the semitrailer was knocked into the cab through the shattered front window. The white specks all across the photograph are little bits of insulation that blew into the cab. (Both, Sam Harrison collection.)

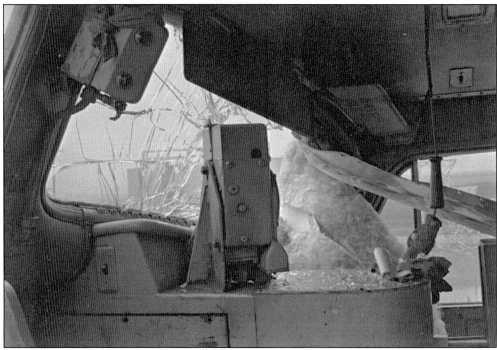

Six

PICKING UP THE PIECES

When accidents did occur, the Illinois Central relied on specialized machinery to clear the wreck site and reopen the tracks. Most of the time, these machines remained far from the public's eye and were tucked away near roundhouses or in freight yards.

The IC was well equipped to clear accidents of any kind. In 1955, the IC had 20 wrecking cranes with lifting capacity ranging between 60 and 150 tons. These cranes were scattered throughout the system so they could respond quickly during an accident. In addition to its own cranes, the IC had agreements with several other railroads to borrow their big hooks. Although they might have been competitors, railroads did work together during emergencies to get the trains rolling again.

During the 1960s, the IC began experimenting with using contractors to clear wrecks. The experiments proved to be successful, and by the 1980s, nearly all wrecks on the railroad were cleared by contractors such as Hulcher Rail Services and R.J. Corman.

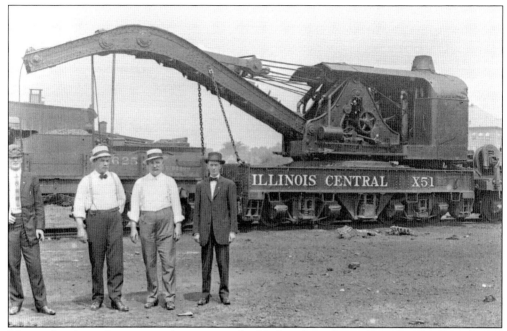

Most railroad wrecking cranes (not just on the IC, but throughout the railroad industry) were built by the Industrial Works Company of Bay City, Michigan. No. X-51 was built in December 1902. The crane had a lifting capacity of 60 tons, which was the standard capacity in the industry at the time. By 1910, the standard lifting capacity had risen to 100 tons.

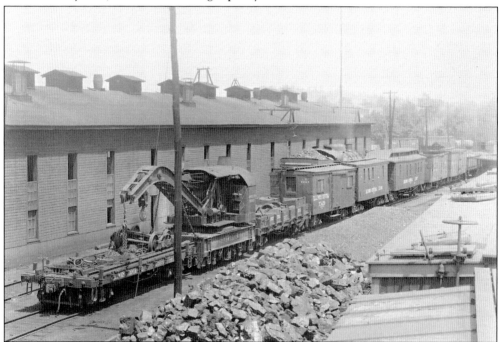

A typical wrecking train of the early 20th century is seen in July 1918 at Central City, Kentucky. In the foreground are the wrecker and the boom car, followed by a flatcar and boxcars with miscellaneous tools and equipment needed to clear a wreck.

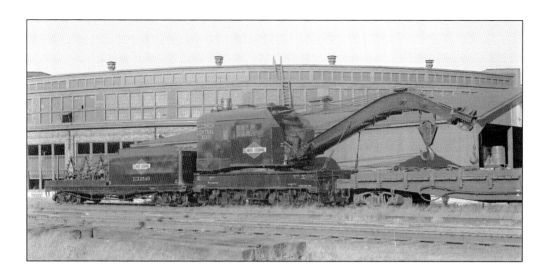

Both cranes seen on this page were built by Industrial Works. No. X-96 was built in July 1913, while No. X-97 was built in June 1918. No. X-96 could lift 100 tons, and No. X-97 could lift 120 tons. Throughout much of its career, No. X-96 was stationed in Centralia, Illinois, while No. X-97 was stationed in Carbondale, Illinois. By the mid-1950s, the IC was rapidly switching from steam to diesel locomotives. This change affected the railroad's ability to maintain and repair its steam-powered wreckers, and both were rebuilt with diesel engines. No. X-97 was rebuilt in March 1956, and No. X-96 followed in May 1957. Both are pictured around 1950 while still steam powered.

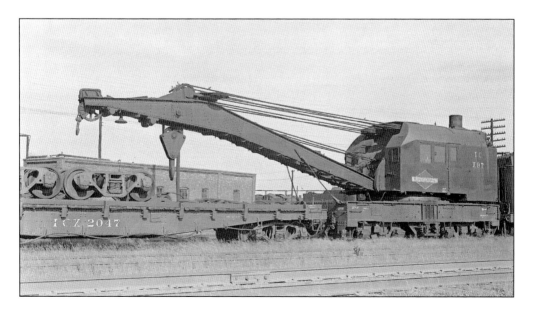

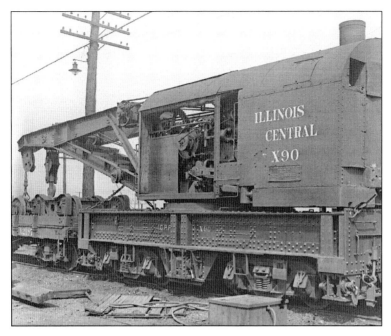

In the early 1900s, the Shaw Electric Crane Company was known for its electric-powered cranes used for industrial purposes. The company then decided to build wrecking cranes for the railroad industry. IC X-89, built in January 1908, was the first big hook built by Shaw. IC bought a second Shaw crane, No. X-90, in November 1911. Both cranes could lift 100 tons.

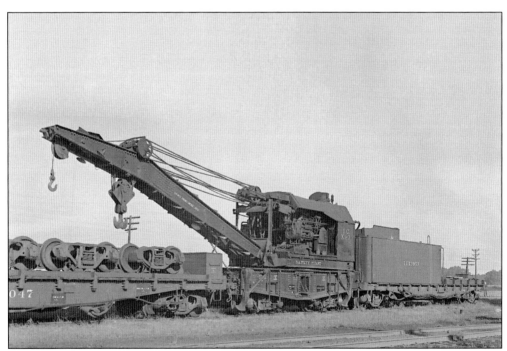

The Bucyrus Foundry and Manufacturing Company was famed throughout the world for its shovels and excavators. These machines were well known for their ruggedness and ability to tackle heavy jobs. (Most cranes used by the United States to construct the Panama Canal were built by Bucyrus). The company also built many railroad wreckers, including No. X-93, constructed in April 1913. This machine had a lifting capacity of 100 tons.

Big hook No. X-89 is seen clearing the wreck of the Panama Limited at Tallahatchie, Mississippi, on November 4, 1937 (see page 26 for more photographs of this wreck). During the derailment, the baggage car on the left came to rest atop locomotive No. 1187. (Chris Thompson collection.)

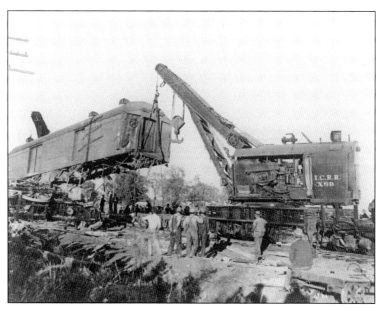

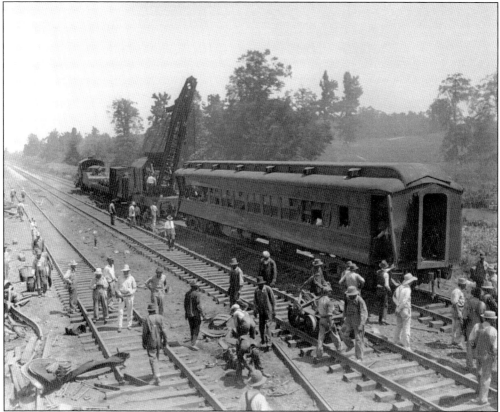

An unidentified big hook is seen rerailing one of the Pullman cars from the 1928 wreck at Mounds, Illinois (pages 49–50). In the early 1900s, Pullman began building steel passenger cars. These cars were larger and safer than older wooden cars but also considerably heavier. This dramatic increase in weight spurred the IC and other railroads to buy larger wrecking cranes in the early 1900s.

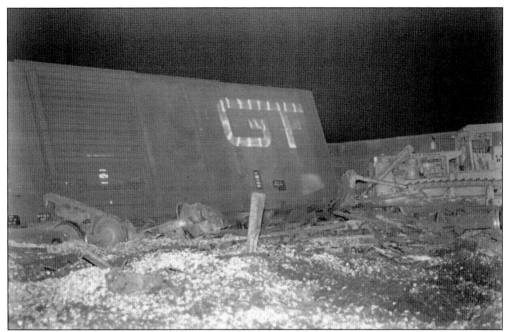

Big hooks nobly served the railroad industry for nearly 100 years. But their massive size and cumbersome operation eventually drove them into extinction. In the 1960s, railroads began using contractors to clear wrecks. Quite often, the contractors could clear a scene more quickly and efficiently than a big hook. The photographs on pages 100–102 were taken at Peotone, Illinois, after a northbound freight derailed 33 cars on the evening of July 27, 1972. On this page, employees of Hulcher Rail Services are busily moving derailed boxcars out of the way so temporary tracks can be laid.

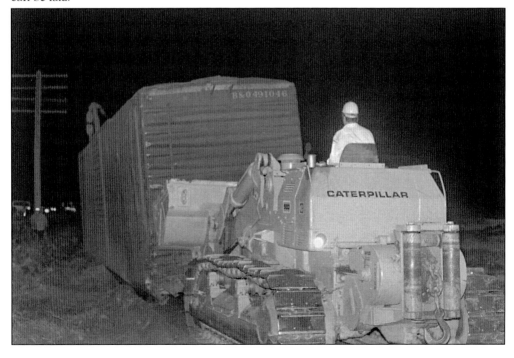

Daybreak at Peotone on July 28 reveals that several of the boxcars are stacked tightly like firewood. Both main lines were damaged, and rails and ties are scattered throughout the area. Despite the damage, temporary tracks will be laid, and the main lines reopened by mid-afternoon.

One of the derailed cars in the Peotone derailment was a tanker loaded with caustic soda. For safety reasons, this car was unloaded before crews attempted to rerail it.

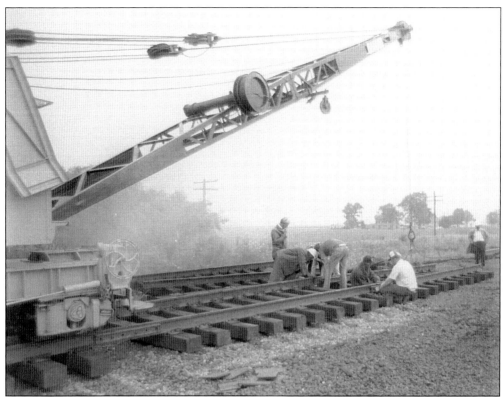

Once the derailed cars had been moved out of the way, it was possible to relay the tracks. A crane is laying sections of panel track, which is being bolted together by a track gang. After the main line has been reopened, more permanent repairs will be made.

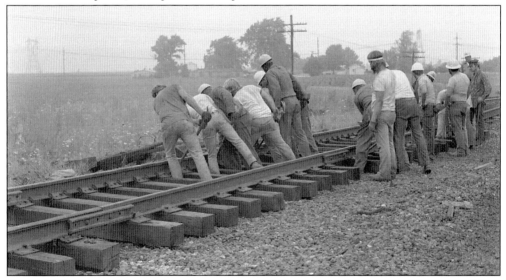

Even with heavy machinery, there is usually a need for raw muscle power and heavy steel bars when clearing a wreck. Under the watchful eye of a track foreman (partially out of view to the right), the men at left give a mighty heave-ho and muscle a section of panel track into position. Meanwhile, another group of men, at right, wait their turn.

Seven
Odds and Ends

Some railroad accidents cannot be neatly classified and are included in this chapter. As noted earlier, the IC crossed several major rivers. These bridges were often hit, but usually the damage was minor. However, as seen on pages 105–106, occasionally these collisions were significant.

Due to space limitations, several photographs of miscellaneous train accidents could not be included in this book. Whenever an accident occurred, no matter how major or minor, the railroad dispatched a photographer to record the scene and all damage. These photographs were typically taken by IC's own claims agents (who settled cases involving property and personal damage) or professional photographers hired by the railroad. These photographs show a part of railroad life not often seen by the general public.

The southbound City of New Orleans narrowly averted a derailment on December 21, 1959, near Gilman, Illinois. While traveling approximately 70 miles per hour, a wheel underneath one of the coaches shattered. One railroad employee was seriously injured in the accident. Herman Fox, a machinist, was headed home to Paducah after working temporarily in Chicago. Fox was in the men's restroom when he was struck by fragments of the broken wheel that were thrown through the floor. These two photographs of the shattered wheel were taken at IC's Burnside Shops a few days after the accident. (Both, Sam Harrison collection.)

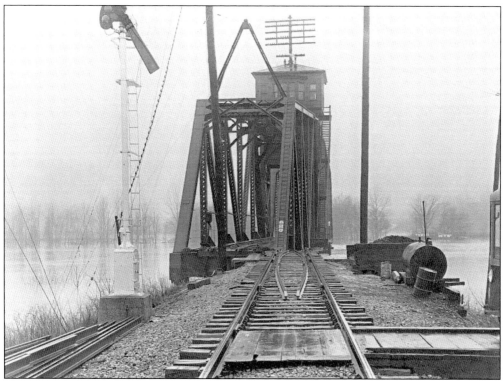

The IC crossed several major rivers throughout its vast system. At most of these locations, the IC constructed drawbridges of varying designs to allow barges to pass by. It was not uncommon for barges to run into these drawbridges, but the damage was usually minor. However, when a barge loaded with steel got caught in floodwaters and struck IC's Cumberland River drawbridge at Eureka on January 12, 1950, serious damage was inflicted. At the time of the collision, the bridge was closed and locked for trains to pass. The above photograph illustrates how the draw span and the span next to it were twisted in the collision. Below, the ends of both damaged spans would normally rest on the pyramid-shaped pedestal. (Both, Sam Harrison collection.)

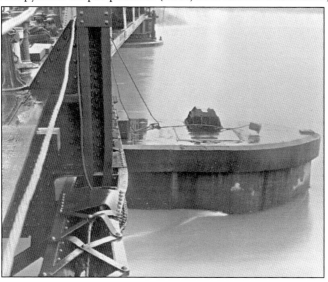

Normally the rails across the Cumberland River drawbridge would be arrow straight, but these two photographs illustrate the heavy damage done to the bridge. Of course, train traffic was halted until the bridge could be repaired. Four passenger trains and a dozen or more freight trains crossed the bridge each day, and thus, management and bridge crews were under pressure to repair the bridge as quickly as possible. The bridge was shut down for three days. During that time, the four passenger trains were annulled and some of the freight was detoured over other lines. (Both, Sam Harrison collection.)

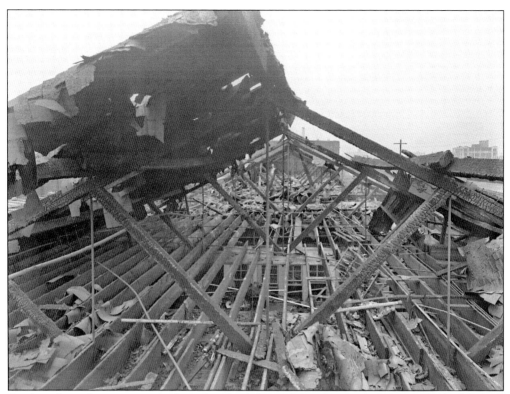

Fire has always been a concern for railroads. A fire in Memphis on August 7, 1950, highlighted the need to reduce fire risks. A junk dealer was demolishing an empty warehouse owned by the IC when the structure caught fire. Approximately two dozen firefighters were inside the warehouse battling the fire when the roof and upper floor collapsed, trapping at least 15 of the men. Dozens of spectators jumped into action to free the trapped firefighters. Several firefighters received serious burns and one, Robert W. Fortune, died of his injuries. An IC company photographer captured these images several days after the fire.

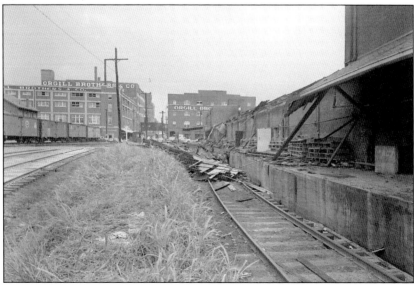

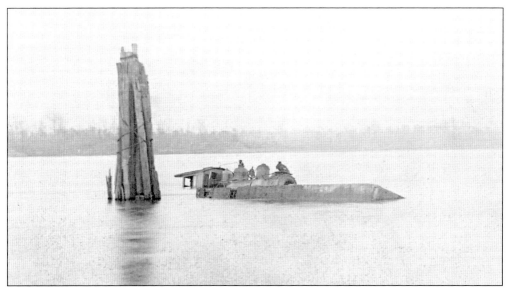

Until 1918, the Illinois Central operated a ferry that crossed the Ohio River between Paducah and Brookport, Illinois. Locomotive 0-6-0 No. 199 was unloading the ferry around 1905 when a string of freight cars lost their brakes. The freight cars rolled into the river and pulled No. 199 with them.

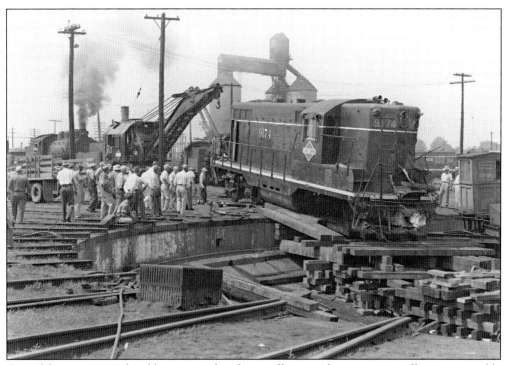

One of the more unpardonable sins in railroading is allowing a locomotive to roll into a turntable pit. But that is exactly what happened on June 13, 1958, in Carbondale, Illinois, when GP9 No. 9174 rolled into the pit. To make matters worse, the roundhouse was only a couple blocks from IC's St. Louis Division headquarters, and a group of managers gathered at the accident site.

Eight

THE 1971 TONTI, ILLINOIS, AMTRAK DERAILMENT

Almost since the birth of the railroad industry, passenger trains have been a money-losing affair for the railroads. By the mid-1900s, several railroads were on the verge of bankruptcy due to losses sustained from operating passenger trains. In response, the federal government formed the National Railroad Passenger Corporation, better known as Amtrak, to take over the nation's intercity passenger trains. However, Amtrak operated only select trains. On the IC, Amtrak decided to operate only the City of New Orleans and a daily train between Chicago and Carbondale, Illinois.

Amtrak assumed operations on May 1, 1971, and as expected, there were problems from the beginning. But nothing compared to the shocking events on June 10, 1971, when the southbound City of New Orleans derailed at the tiny community of Tonti, Illinois. Ten passengers and the conductor died, and 163 others were injured. Almost immediately, investigators discovered that an axle on the train's lead locomotive had locked up. This created a "false flange" on the steel wheel. Flanges help steer a train's wheel, and if there is a false flange, then a train may be steered in the wrong direction. As the train passed over a switch, the false flange "picked" the switch, causing the train to derail.

The number of dead and injured passengers might have been higher if it were not for the quick and skillful response of emergency personnel in Salem, the nearest town. The town had recently had an emergency drill and was well prepared for an emergency of this type. In its report on the Tonti derailment, the NTSB praised the town's residents and urged other communities to adopt their own emergency plans.

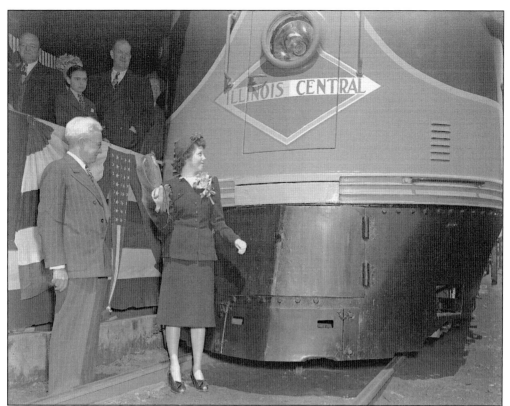

The Illinois Central christened the City of New Orleans with ceremonies on April 25, 1947, in Chicago and New Orleans. In Chicago, the train was christened by Jane Johnston, the daughter of IC president Wayne A. Johnston. Two days later, the train entered service on an earth-scorching schedule of 15 hours, 55 minutes between Chicago and New Orleans, a distance of 921 miles. (Chris Thompson collection.)

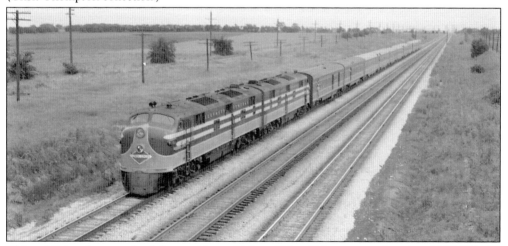

This publicity photograph of the southbound City of New Orleans was taken in mid-1947. In its original configuration, the train left Chicago with three locomotives and 11 passenger cars. At Carbondale, Illinois, the train picked up a coach from St. Louis, and at Fulton, Kentucky, the train picked up two coaches from Louisville. This procedure was reversed for the northbound train.

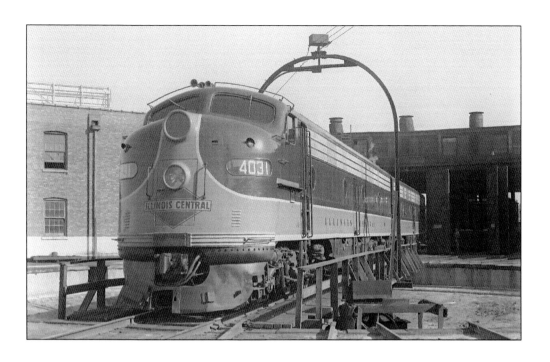

In June 1952, the IC received E8A No. 4031 from the Electro-Motive Division of General Motors. The paint was still shiny when the locomotive posed on the turntable at the Twenty-seventh Street roundhouse in Chicago around 1954. The same locomotive is seen below on the afternoon of June 10, 1971, lying on the engineer's side after derailing at Tonti. (Both, Sam Harrison collection.)

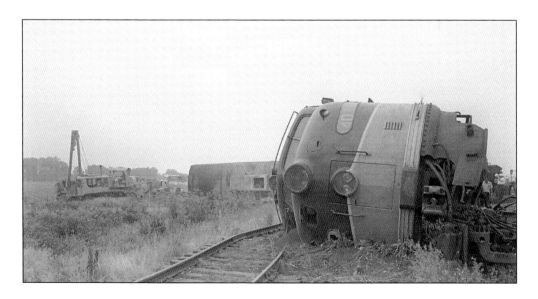

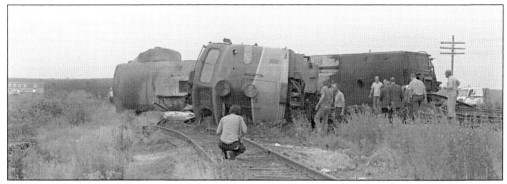

After the derailment, locomotive No. 4031 came to a rest roughly parallel to the main line, about 30 feet on the west side of the tracks. The second locomotive, E9B 4109, flipped on its side and caught fire. The third and fourth locomotives also derailed but remained upright. (Sam Harrison collection.)

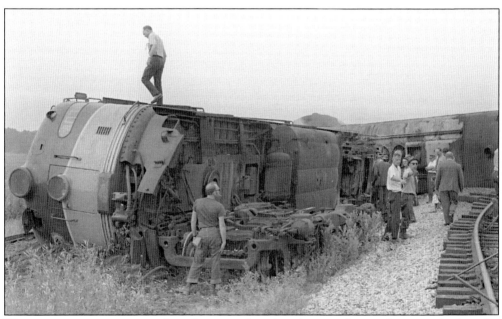

The circumstances are certainly unfortunate, but this photograph provides a rare look at the underframe of lead locomotive E8A No. 4031. The front truck fell off during the Tonti derailment, but the rear truck remained attached. In the center are two water tanks that held a combined 1,350 gallons of water for a steam generator. Sandwiched between the water tanks is a smaller tank holding 1,200 gallons of diesel fuel. (Sam Harrison collection.)

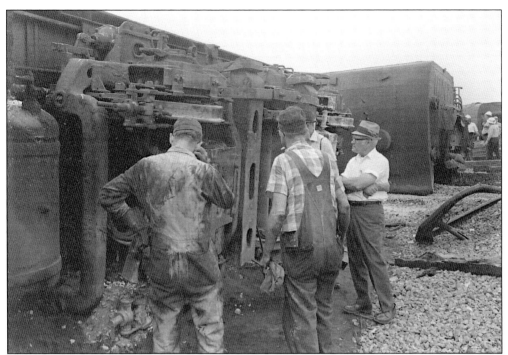

Once the casualties had been evacuated from the scene of the Tonti derailment, attention shifted to finding the cause of the derailment. Investigators quickly focused on the rear truck of lead locomotive No. 4031, and more specifically the lead axle. One of the two wheels on this axle had a false flange, created when the axle locked up near Mason, Illinois, approximately 27 miles north of the derailment. The frozen axle was then dragged at speeds up to 100 miles per hour. When the train passed over a switch at the derailment point, the false flange caused it to derail. The false flange can be seen near the center of the photograph below. (Both, Sam Harrison collection.)

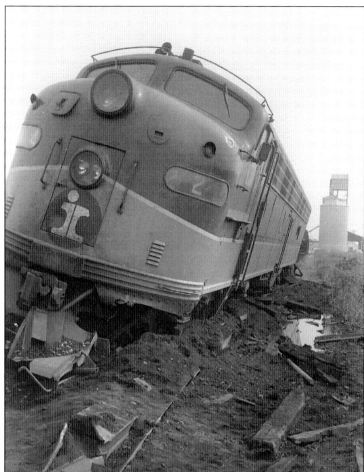

The fourth locomotive in the Tonti derailment was E10A No. 2024, seen here. After the derailment, all four locomotives were towed to the IC's main locomotive shop in Paducah and were eventually scrapped. (Sam Harrison collection.)

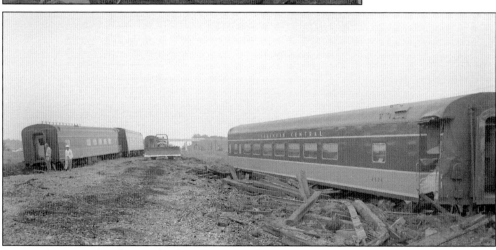

During the Tonti derailment, the first seven cars flipped onto their sides. The next five cars also derailed and jackknifed but remained upright. Coach No. 2620 sits on the right in this photograph while coach–lunch counter car No. 3335 and the last three coaches of the train can be seen to the left. (Sam Harrison collection.)

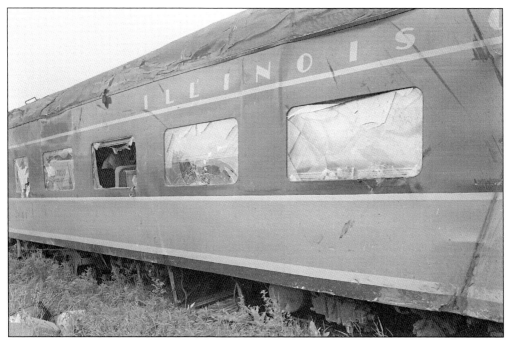

Rail transportation is one of the safest forms of transportation, but the Tonti derailment uncovered several weaknesses with passenger car designs. According to NTSB report RAR-72-5, six people were killed when they were thrown outside of their cars through the side windows. Three others died when the end of the car they were riding in was crushed, and another died after being thrown around inside the car. The 11th person died when hit by a cross tie that was pushed into their car. Broken rails penetrated at least one car, injuring several passengers. (Both, Sam Harrison collection.)

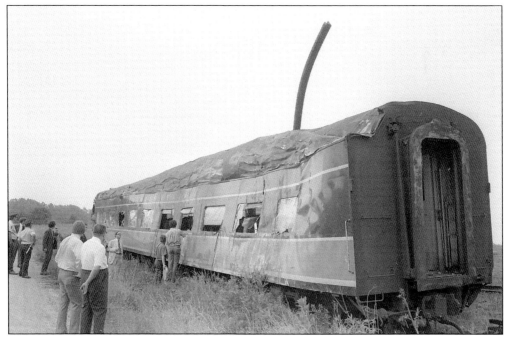

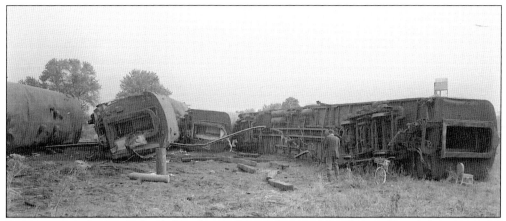

Cars were tossed around like children's toys during the Tonti derailment. From left to right, the cars visible in this photograph are diner No. 4203, coaches No. 2616 and No. 2622, and baggage car No. 1822. Note the rails that penetrated coach No. 2616. Also note the man at right, who apparently is a local resident. Securing accident scenes is always a challenge for emergency workers, for accidents tend to draw a crowd. (Sam Harrison collection.)

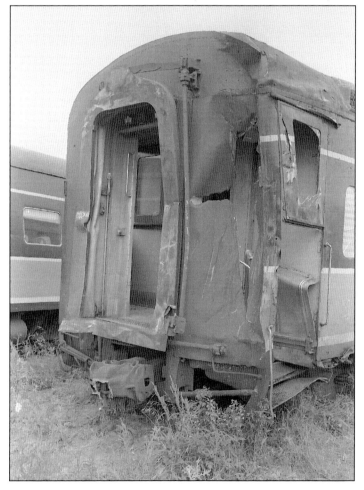

The violence and power of the Tonti derailment can be seen in this photograph. Underneath the doorway at the end of the car is the coupler. For decades, passenger cars have used special couplers designed to keep cars coupled together in a derailment. During the Tonti derailment, one of the couplers twisted and broke, leaving just the jaws connected together. (Sam Harrison collection.)

An unidentified emergency worker was photographed standing next to an emergency vehicle. In its report on the Tonti derailment, the NTSB had high praises for local first responders and the residents of Salem, the nearest town to the derailment. Word of the derailment reached the local police at approximately 12:27 p.m., and immediately the local volunteer fire department and the police departments were dispatched to the scene. Several residents also went to the scene and helped evacuate wounded passengers. Passengers with minor injuries were treated at a portable field hospital set up in Salem's high school. This allowed the local hospital to focus on treating serious injuries. When the local hospital, which had only 37 beds, filled up, injured passengers were transferred to area hospitals. The NTSB concluded its report by stating, "The Safety Board commends the town of Salem and all those persons who assisted after the accident for their exemplary response to the emergency created by this accident." (Sam Harrison collection.)

On the day of its tragic derailment at Tonti, the City of New Orleans was transporting a casket with the body of an unidentified person. After the wreck, the case with the casket was moved to a nearby grade crossing where it could be picked up and removed from the derailment site.

Baggage and mail from the baggage car are also piled up, waiting to be taken away. The practice of carrying caskets aboard passenger trains dates back to the birth of the railroad industry and continues today aboard some Amtrak trains. (Sam Harrison collection.)

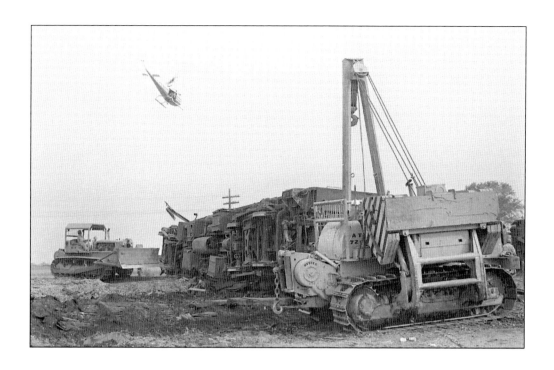

The Tonti derailment blocked one of IC's busiest main lines, and management was eager to open the tracks as soon as possible. Above, a conventional bulldozer and a side-boom are working together to move one of the derailed passenger cars out of the way. These machines can be repositioned much faster than a traditional big hook. Additionally, they can work in areas where the track has been destroyed, where a big hook would have to wait until the tracks have been repaired before moving forward. Below, two derailed cars have already been moved out of the way and crews are about to work on a third. Once the cars have been moved, crews can grade the right-of-way, lay panel track, and reopen the tracks. (Both, Sam Harrison collection.)

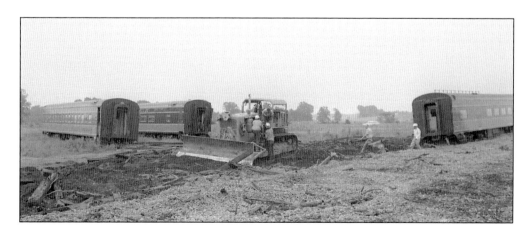

Nine

THE 1972 CHICAGO SUBURBAN COLLISION

On July 21, 1856, the fledgling Illinois Central Railroad inaugurated suburban train service between downtown Chicago and suburbs to the south. Legend has it that not a single passenger rode that inaugural run, and IC even tried to cancel the service. However, the service slowly took root, and within a few years, IC's suburban service had become a Chicago tradition.

In 1926, the wooden cars and steam locomotives of the old trains were replaced by new steel cars. These cars drew electric current from an overhead catenary and were hailed far and wide for their modern design. However, by the mid-1960s, the cars were showing their age. With financial help from local communities and the federal government, the railroad placed an order for 130 new cars from the St. Louis Car Company. The cars were nicknamed "Highliners" due to their bi-level construction.

The new cars experienced braking problems almost from the beginning. Several were damaged during a test run, and when the cars finally entered service, trains routinely overshot their station stops.

At 7:06 a.m. on October 30, 1972, train No. 416, with four new Highliners, departed South Chicago headed towards downtown Chicago. At the Twenty-seventh Street station, the train overshot the platform. The engineer contacted the conductor and asked for permission to back up to the station. The conductor granted the permission and the train began backing towards Twenty-seventh Street.

Meanwhile, train No. 720, with six older cars, had departed South Chicago at 7:15 a.m. After departing Stony Island Avenue, the train was scheduled to run nonstop to Twelfth Street. As the train approached Twenty-seventh Street, the engineer of train No. 720 saw train no. 416 backing towards the Twenty-seventh Street station. Train No. 720 applied the emergency brakes, but it was too late. Train No. 720 rear-ended train No. 416, the lead car of train No. 720 plowing through the rear car of train No. 416. Forty-five passengers died, and 332 persons were injured. The wreck was the deadliest in IC's history and one of the deadliest wrecks to happen in the Chicago area.

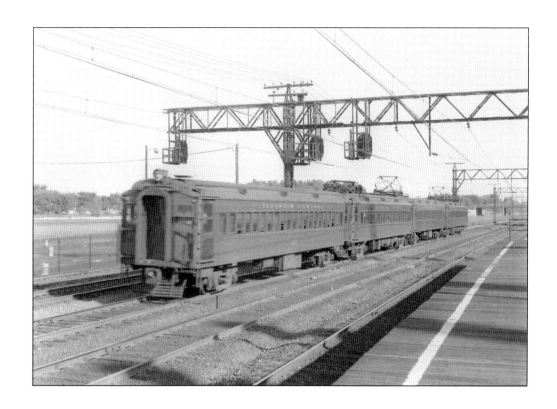

Two different types of railcars were involved in the deadly Twenty-seventh Street collision. Train No. 720 (the second train) had six cars, similar to those above. These cars were among a fleet of 130 cars purchased when IC electrified its Chicago suburban service in 1926. Over the years, these cars were frequently called "Wickerliners" due to their wicker seats. In 1970, the St. Louis Car Company won a contract to build replacements for the aging Wickerliners. The new cars quickly gained the nickname Highliners due to their height and double-deck construction. (Both, Sam Harrison collection.)

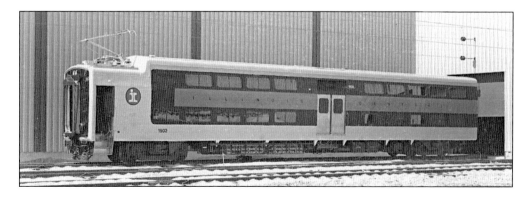

During test runs, the new Highliners experienced several problems, mostly with their brakes. On September 7, 1971, a test train had braking problems and hit the bumping post at Randolph Street station with enough force to create wrinkles in the exterior steel siding of one of the cars. Additionally, part of the steel siding split away from the underframe. (Sam Harrison collection.)

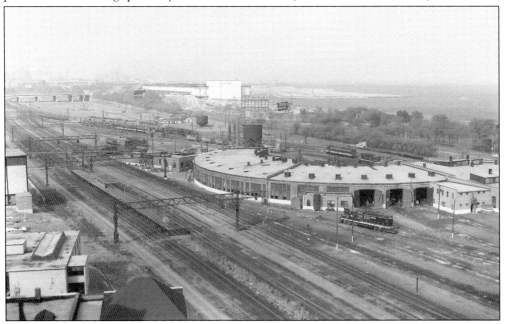

This view of the Twenty-seventh Street station and surrounding buildings was taken around 1964. The station itself is visible at lower left. A pedestrian bridge over the tracks provided access to the station. IC's Twenty-seventh Street roundhouse can be seen on the right.

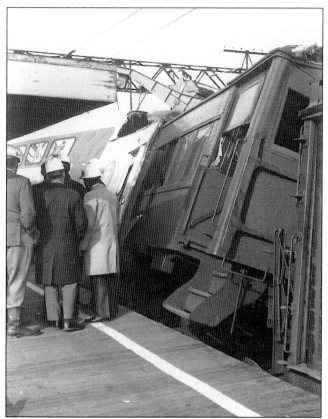

These two photographs illustrate the destructive forces of the Twenty-seventh Street collision. NTSB report RAR-73-5 described the sequence of events: "The leading coupler of the first car of train 720 was broken off by the impact, and the car overrode the underframe of the rear car of 416. The first car of 720 then sheared off the collision posts on the rear car of 416, veered slightly to the right, and moved through the passenger section." By the time train No. 720 came to a stop, approximately two-thirds of its lead car (which was 72 feet long) had become lodged in the rear car of train No. 416. Considering this chain of events, it is not surprising that all 45 fatalities occurred in the rear car of train No. 416. (Both, Ted Lemen photograph.)

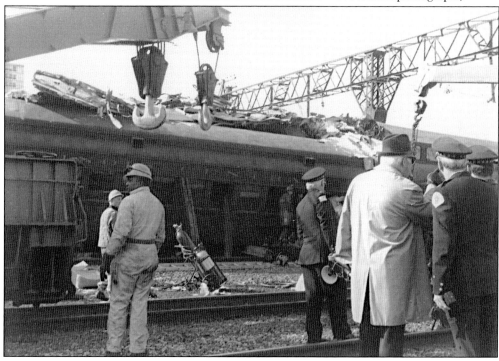

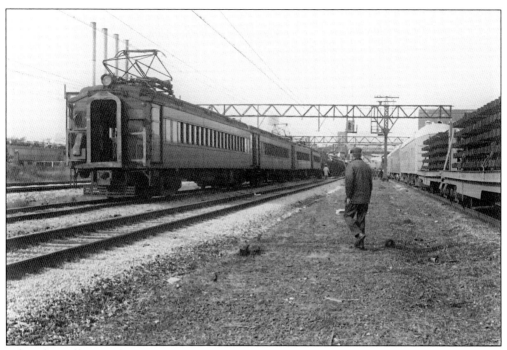

After the collision, the wreck train from Markham Yard on the south side of Chicago was immediately moved to the crash site. The wrecker crew was accustomed to moving wrecked freight cars out of the way as quickly as possible. However, most of the crew had to stand by and wait as firefighters, policemen, doctors, nurses, and railroad workers risked their safety to remove victims. These men crawled into tight spaces and had to navigate through mangled piles of shredded metal. In addition to power equipment, rescuers had to use simple tools like crowbars, hammers, and blocks of wood to pry open the debris. (Above, Ted Lemen photograph; below, Chris Thompson collection.)

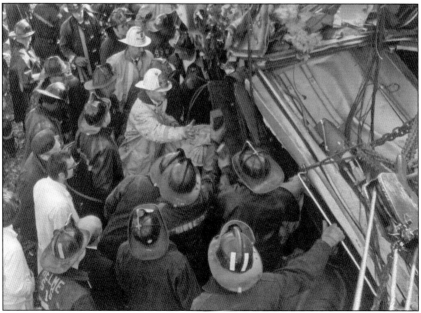

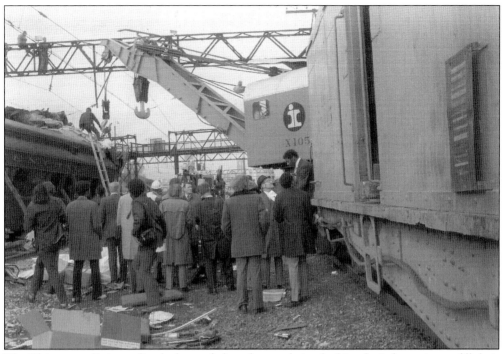

The Chicago media immediately descended on the wreck site, looking for information to fill their newspapers and television and radio reports. Here, a small crowd of reporters and photographers gather next to big hook X-105. (Chris Thompson collection.)

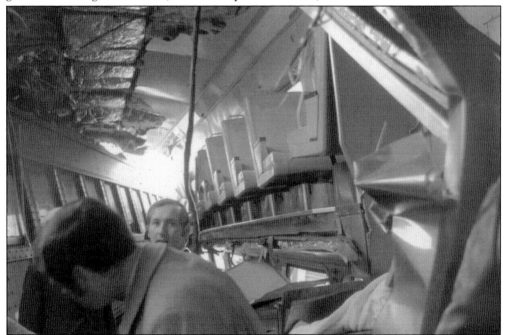

This rare photograph was taken inside the rear car of train No. 416. The photographer is standing roughly in the middle of the car. To the left is the front car of train No. 720. The photograph shows how the car was split apart during the collision. (Chris Thompson collection.)

These shopping bags inside the rear car of train No. 720 were among the personal items left behind after the crash. It is unknown if their owner survived the collision. (Chris Thompson collection.)

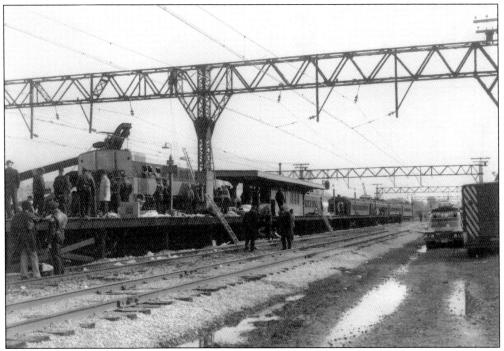

This view from the west side of the tracks reveals only some of the chaos from the day. The wooden station in the center obscures the two cars that collided. Rescue and recovery efforts continued into the afternoon hours. (Ted Lemen photograph.)

Discover Thousands of Local History Books Featuring Millions of Vintage Images

Arcadia Publishing, the leading local history publisher in the United States, is committed to making history accessible and meaningful through publishing books that celebrate and preserve the heritage of America's people and places.

Find more books like this at
www.arcadiapublishing.com

Search for your hometown history, your old stomping grounds, and even your favorite sports team.

Consistent with our mission to preserve history on a local level, this book was printed in South Carolina on American-made paper and manufactured entirely in the United States. Products carrying the accredited Forest Stewardship Council (FSC) label are printed on 100 percent FSC-certified paper.